X

D1499298

X

Images

in the Heavens,

Patterns

on the Earth

The I Ching

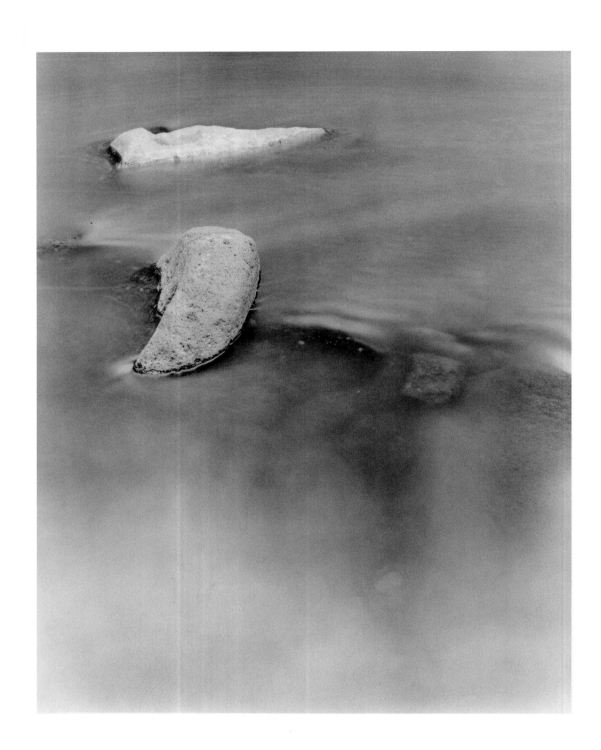

Images

in the Heavens,

Patterns

on the Earth

The I Ching

Photographs by
Janet Russek and David Scheinbaum

With an essay by Jonathan Porter
and commentaries by Janet Russek

Museum of New Mexico Press • Santa Fe

We dedicate this book
to each other
and to the natural world
as our teacher.

Contents

Preface

Use this book to always see other sides and at the same time to always be able to see inside.

Soon after we first met, David shared his experiences in the use of the I Ching and wrote the above inscription in a copy he gave me as a gift. After he taught me how to use it, the Book of Changes became a companion to both of us and remains so to the present day.

We have consulted the I Ching for many of the major decisions in our lives, not as a last word or an authoritative answer but for assistance in our decision-making process. The ancient Chinese wisdom is uncanny in its ability to enlighten a situation, challenging us to question, expand our perspectives, consider the impact of our decisions on those around us, and ponder our own lives in the past, present, and future. The I Ching is an oracle, but for us it has also served as a friend, confidant, and wise counselor.

Attempting to understand its workings can be a great distraction. How does one explain the many mysteries encountered in life? We simply accept the fact that for each question we have asked, the I Ching has offered illumination, not in the sense of "yes or no" or "do this or do that" but rather along the lines of "why, how, and what if?"

Among the I Ching's remarkable qualities is its capacity to speak universally through lyrical allegories of the natural and human worlds. Each person who reads its wise words will draw a different meaning. Likewise, in this book we claim only to present our personal interpretations of the sixty-four hexagrams that have inspired these photographic images. We are neither scholars of the I Ching nor authorities on its use. Our hope is that these visual companions will offer an additional metaphorical dimension to consultations with the I Ching.

Conceiving and compiling this volume involved a long and personal journey. The images in this book, taken between 1972 and 2003, provide a brief retrospective of our lives. They represent monumental decisions that confronted us as we have grown. When we began to edit the images, we hoped each photograph would perfectly embody each hexagram. Just as the I Ching suggests many aspects of an issue, we know that there are other photographs that might have served. We finally selected images that we felt not only illuminate the hexagrams but simultaneously tell a story about our lives with not a literal but an emotional truth.

David and I have collaborated in many areas—as husband and wife, parents, business partners, and artists—and this book is the fruition of a dream, of the connection we feel to one another, sealed by a gift given more than twenty years ago.

Introduction
Jonathan Porter

When in early antiquity Pao Hsi ruled the world, he looked upward and contemplated the images in the heavens; he looked downward and contemplated the patterns on earth. He contemplated the markings of birds and beasts and the adaptations to the regions. He proceeded directly from himself and indirectly from objects. Thus he invented the eight trigrams in order to enter into connection with the virtues of the light of the gods and to regulate the conditions of all beings. (Wilhelm 1967, 328–29)

Chinese legend tells us that the primordial culture hero Fu Hsi (Pao Hsi), upon observing the naturally occurring patterns in the heavens and on the earth, invented the trigrams, the eight combinations and permutations of three divided and undivided lines, as emblems of cosmic processes. Later, the eight trigrams were joined to form the sixty-four hexagrams of six divided and undivided lines. Later still, in the eleventh century B.C.E., the architects of the new Chou order, King Wen and his son the Duke of Chou, who overthrew the ancient Shang dynasty, assembled these emblems, or diagrams, in a book of divination

that came to be called the Chou I, the "Changes of the Chou," and added text and commentaries to the individual lines. Finally, eight hundred years later, in the waning years of the Chou, during an era marked by vigorous philosophical, political, and social discourse among representatives of various schools of thought, more extensive commentaries and explanatory texts were appended to the work. These additions, which were attributed to Confucius (551–479 B.C.E.) and his disciples, brought the work, now known as the I Ching, the "Classic of Change," into its present form.

The history of the I Ching, part myth and part fact, suggests two explanations for its origins that reflect divergent but complementary interpretations of its significance. In one view, the I Ching evolved from divination practices used by the Chou people over many centuries and thus was a compilation of numerous individual records that gradually achieved coherence. This origin is still evident in the references to specific incidents and events found in the explanations of the lines of the hexagrams. In another view, the I Ching is a consciously composed work attributed to one or more authors—King Wen and the Duke of Chou typically—to which more extensive commentary was later added.

Whatever truth or fantasy may lie in legends of its origins, the I Ching is unquestionably a very ancient book in its fundamental conception. If the interpretations and commentaries date from a later time and reflect the ideological and political agenda of their composers, the constituent elements of the diagrams no doubt arose in the techniques and individual records of divinations collected together over an extended period of time.

Hence, the I Ching is really two books in one: a divination manual and a wisdom text, the latter apparently having evolved from the former, much earlier work. By the early imperial era of the Han (206 B.C.E.–220 C.E.), the I Ching had acquired the status of a classic alongside the other venerable texts of the early Chou, including the Shu Ching (Book of Documents), the Shih Ching (Book of Poetry), the

Ch'un Ch'iu (Spring and Autumn Annals), and the Chou Li (Rites of Chou). In subsequent ages, the I Ching became the most esteemed of the classics, in spite of—or perhaps because of—its cryptic nature. Throughout the imperial age, Confucian scholars and literati continued to ponder its meaning, and a vast corpus of commentary and interpretation on the work, often driven by changing intellectual and scholarly movements, resulted. As late as the last imperial period of the Ch'ing (1644–1912), the I Ching was the subject of intense textual exegesis associated with the new intellectual fashion of evidential research, yet it never lost its powerful scriptural authority.

The I Ching, as divination manual and as a book of philosophy, continued to have diverse followings down to the present. Some commentators have insisted on separating the two conceptually, if not actually, rejecting the importance of one or the other aspect. Others adhere to the view of Chu Hsi, the great Confucian synthesizer and founder of the neo-Confucian movement in the twelfth century, who maintained that the two aspects were inseparable.

As a divination manual, the I Ching originated from a very specific historical context provided by the interaction between Shang and Chou cultural elements. The Chou people arose as vassals of the Shang, the civilization that dominated north China along the Yellow River basin from the seventeenth to the eleventh centuries B.C.E. The Shang was ruled by a powerful, centralized dynastic state whose kings derived their legitimacy from primal ancestor deities. To communicate with their divine royal ancestors and thereby sustain the legitimacy of their dynasty, the Shang kings employed a method of divination using animal bones. Large bones of cattle, including the scapula and leg bones, and the plastron of tortoises were flattened and dried. To consult an oracle, the shaman conducting the ceremony made an incision on one side of the flat bone. A hot instrument was applied to the incision that produced cracks radiating from the incision. These cracks were interpreted by the shaman as a response by the ancestors to a question or problem posed by the king. Often the question and the response, and sometimes

the outcome, were inscribed on the bone and kept as a record. Such "oracle bones," dating as far back as the seventeenth century B.C.E. and comprising the first written records of Chinese civilization, establish the chronology as well as a picture of much of the culture and life of the Shang ruling class.

The Chou possessed different cultural and social traditions from the Shang. Their method of divination involved the complex manipulation of fifty stalks of the yarrow plant to produce a hexagram, a diagram of six divided and undivided lines. Divided lines represent yin, the female, passive principle and earth; undivided lines represent yang, the male, active principle and heaven. A question was posed and the response was derived by consulting commentaries on the meaning of the order and number of yin and yang lines.

As distinct from the Shang, the Chou method required no intermediary. Furthermore, it grounded the ultimate meaning of the hexagrams not in the Chou (or Shang) divine ancestors but in a more universal conception of Heaven (*t'ien*) as the foundation of the moral order of the cosmos. This secularization of the shaman's priestly function put the cosmic order within the reach of lay interpretation.

When the I Ching is used as a divination manual, the visual component is preeminent. According to legend, Pao Hsi contemplated the images in the heavens and the patterns on the earth, the markings of the birds and beasts and their regional adaptations, and translated these observations into concrete symbols that come to us as the trigrams and hexagrams.

The Chinese traditionally viewed the cosmos as well as metaphysical abstractions in concrete, highly visual terms. The Chinese language both encouraged and was itself the product of this approach. Chinese characters are visual representations of things even when they refer to nonvisual concepts. Common nouns, verbs, prepositions, adjectives, adverbs, and articles — to the extent that they can be differentiated in this way in Chinese — are concrete images of things, actions, and qualities regardless of usages. Although the reader of a Chinese text may not

be immediately conscious of the representational significance of the characters, Chinese characters never lose their concrete, visual significance, however abstract their immediate application may be. Characters possess a powerful visual quality as organized patterns representing aspects of the surrounding world.

The hexagrams, unlike Chinese written characters, are not representations of things but nevertheless refer indirectly to features that Pao Hsi supposedly observed in the natural and human worlds. In this respect the hexagrams provide a visual reflection of the cosmos. Viewed as a sort of "genetic code" of the cosmos, the hexagrams can be seen as a means of predicting its operation in much the same way that the genetic structure of a biological organism may be used to understand its features and behavior. Further, analogous to the way that genes assume a concrete, helical structure in which combinations constantly change, the hexagrams have a concrete structure while the meaning of lines in relation to each other constantly changes.

In using the I Ching for divination, after deriving a hexagram in response to a question or situation, one is confronted with a brief but cryptic "judgment," a short evocation of the symbolism of the "image," and finally a series of equally cryptic statements interpreting each line of the hexagram, starting from the first line at the bottom, within the context of the other lines. Imbedded in the ostensibly simple diagrams are multiple layers of images that must be deciphered and applied to one's own circumstances.

The I Ching, then, is about situations, not about preordained outcomes. Hence, it is not a method of understanding the inexorable will of a divine power in whose hands one's fate lies or a way of reading what is already "written." Rather it deals with the contingencies within an unfolding situation with potential for changes depending on the actions contemplated. The lines of the hexagram, read from bottom to top, describe the trajectory of a situation, where choices among contingent actions exist at each stage. Each line may be transformed from divided to undivided or vice versa in order to explore the potential

consequences of changes. Offering in this way almost endless possibilities for understanding virtually any situation, the system of the I Ching offers a kind of "science of situations."

Viewed from such a perspective, the I Ching surpasses its function as divination manual and becomes a book of cosmology or philosophy. In this dimension, the visual aspect ceases to be so important and instead the more abstract moral order of Heaven that lies behind the hexagrams and commentaries becomes a new focus. Longer commentaries, known as the "Ten Wings," attributed to Confucius and appended to the text, deepen and broaden the philosophical import of the work. And yet, in a characteristically Chinese way, this later philosophical stratum is still very dependent on concrete images and particular contexts.

The I Ching came to be valued as a wisdom book during a tumultuous historical era. When the Chou conquered the Shang in the eleventh century B.C.E., they claimed moral authority derived from Heaven (*t'ien*) as their justification for overthrowing their former overlords. Because the Shang lineage had declined in virtue, with the last kings having violated the moral imperatives of rulership, the Chou asserted that they had received a mandate from Heaven to rule "all under Heaven." In so doing, the Chou kings conceived a new political-moral order founded not on a dynastic descent from a divine ancestor but on a universal moral system transcending China itself.

Further, because the Chou acquired an empire much larger than that previously ruled by the Shang, to rule such an extensive territory the Chou founders were forced to make their relatives and supporters vassals to govern feudal states. In the beginning there were perhaps several hundred such vassal states, all under the hegemonic authority of the Chou kings, who ruled this decentralized system from their original homeland in the northwest.

This was an age when virtue and order prevailed under the benevolent rule of sage kings. The early centuries of Chou rule were relatively harmonious. The I Ching was elaborated and refined during

this period, with records of divination, including specific situations and judgments appended to the hexagrams, reflecting the prevailing order. In time, however, the initial stability of the Chou order was undermined by economic growth and political changes. The more powerful individual states absorbed their weaker neighbors, resulting in disorder and conflict. By the end of the fifth century B.C.E., at the beginning of the Warring States period, warfare had become continuous, as the larger states challenged the Chou for supremacy. Toward the end of this process in the third century B.C.E. the surviving seven states were locked in a brutal contest to rule all under Heaven. Throughout these increasingly chaotic times, vast social and economic changes were underway that laid the foundations for the new imperial bureaucratic order that would later emerge from the collapse of the Chou.

In response to the growing disorder and changes overwhelming society, a vigorous intellectual debate developed that sought to diagnose the troubled times and offer solutions. To such men as Confucius, who lived at the end of the spring and autumn period in the fifth century B.C.E., as well as to others such as the Taoists, who espoused views that diverged from his, the I Ching and other texts passed down from the early Chou were a precious legacy that preserved the memory of better times. As such, these texts were viewed as essential resources from which the social and political order of the early Chou founders, now venerated as sage kings and culture heroes, might be reconstructed. In this context, the I Ching, mysteriously embodying the harmonious moral system of antiquity, gradually became a wisdom text of virtually unchallenged scriptural authority.

According to later tradition, Confucius was supposed to have supplied the appended texts of the I Ching to expand on what he viewed as its relevance for the troubled times in which he lived. In fact, it is clear that much of this material owes more to the highly syncretic spirit of the Han period, which followed the abrupt collapse of the brief but violent imperial unification under the first emperor, Ch'in Shih-huang-ti. Han scholars and cosmologists of the third and second centuries B.C.E.,

nominally Confucian in their affiliations but deeply influenced by Taoist and Naturalist thinking from the Warring States period, created a complex metaphysical synthesis to provide ideological support for the new imperial state.

It is difficult at this point to determine whether the I Ching was expanded and interpreted by Han cosmologists to encompass the new syncretic thought of the Han because it was already esteemed as an ancient source of moral and natural concepts, or whether the I Ching was venerated because it was a primary basis for that system of thought. Whatever the case, the I Ching is a major repository of the distinctive Chinese cosmology that emerged in the Han era but with elements rooted in the origins of Chinese civilization itself.

In Chinese cosmology, the universe is uncreated, spontaneously self-generating, ordered and self-contained yet perpetually in motion, and imbued with an inherent moral order. In addition, time is not a teleological process but synchronic—change occurs within the interrelated parts of a closed hierarchical system. The I Ching reflects this cosmology in that the components of the hexagrams, the yin (divided) and yang (undivided) lines, while fixed in number are in a perpetual state of flux.

Further, the Chinese cosmos is structured as an organic hierarchy in which everything has its proper place but is affected by its changing context. Similarly, the hexagrams do not stand alone but relate to each as part of a continuously changing process. In fact, reflecting the visual quality of the I Ching, the dynamic arrangement of the diagrams could be viewed as a fingerprint of the cosmological order.

Although the hexagrams and the commentaries on them have been appreciated as a kind of universal language of the cosmos, one may ask to what degree the I Ching is so culturally grounded in a unique Chinese worldview that it is relevant only to understanding the Chinese mind. With respect to this question, it may be useful to distinguish between its function as a wisdom book, with layers of interpretations linked to the emergence of a distinctive Chinese cosmology, and its function as a universally applicable divination text that is less

encumbered by the agendas of later commentators yet still the product of particular historical circumstances.

Commenting on the problem of interpreting the I Ching's symbols, Confucius observed that "writing (*shu*) cannot fully express the meaning of speech (*yen*); speech cannot fully express the meaning of ideas (*i*)." After a student then asked whether it was possible to apprehend the ideas of the sages, Confucius responded, "The Sages established the images (*hsiang*) in order to fully express the meaning of their ideas. They devised the diagrams (*kua*) in order to fully express the distinction between true and false, and attached judgements (*tz'u*) to them in order to fully express their speech." This statement reflects the complex dynamic pervading the I Ching between verbal expression, symbolic expression, and something perhaps even more elusive that lies behind them both. In this epistemological structure, written words are approximations for spoken words, which in turn are only approximations of the ideas themselves. For the purpose of refining expression of the ideas, verbal images evoking them were created, visual diagrams were devised, and judgments were appended to enhance the spoken words. Accordingly, a symbiotic relationship exists between verbal images and visual diagrams in the I Ching. The images are universalized concepts given concrete expression in the diagrams. But while the hexagrams are fixed in number, since they are mathematically derived, the images are not and could be anything that illuminates the diagrams, including mental images that the words evoke or visual images such as photographs.

If, after all, the purpose of the I Ching is to understand human situations in the context of the processes of nature, then presumably any means to this end that elucidates the hexagrams is appropriate. Janet Russek and David Scheinbaum have accomplished this end with unusual insight, based on their long mutual involvement with the I Ching.

Images

in the Heavens,

Patterns

on the Earth

The I Ching

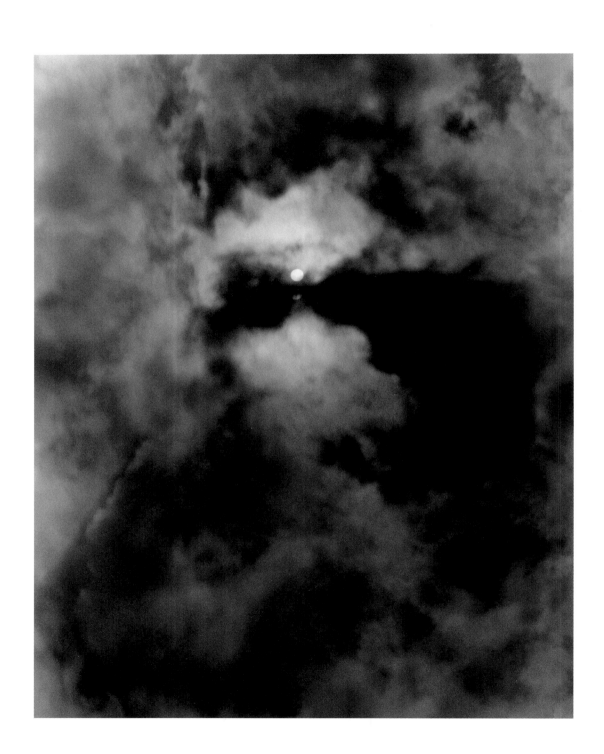

1

CH'IEN | THE CREATIVE

CH'IEN | The Creative, Heaven

CH'IEN | The Creative, Heaven

Primal power

Light, active, strong and of the spirit

Heaven

Unrestricted energy

Motion

The power of time and the

power of persistence through time

Duration.

The clouds pass and the rain does its work, and

all individual beings flow into their forms.

WILHELM, PAGE 4

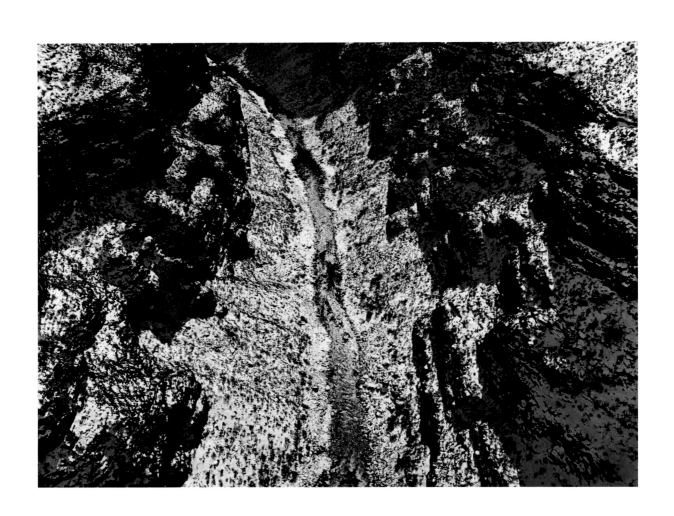

2

K'UN | THE RECEPTIVE

K'UN | The Receptive, Earth

K'UN | The Receptive, Earth

Nature

Earth

Receptive, yielding, and devoted

Connected to the west and south

and the tenth month

There is increasing darkness

and the year is ending

Service.

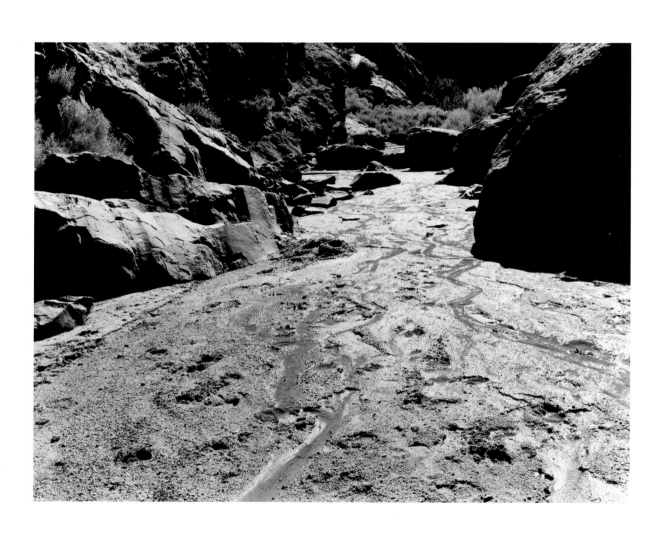

3

CHUN | **DIFFICULTY AT THE BEGINNING**

K'AN | The Abysmal, Water

CHÊN | The Arousing, Thunder

Difficulty arises when heaven and earth,

light and shadow unite

Birth

Chaos

Separation and unity are integral

to finding one's place

in the universe.

When it is a man's fate to undertake such new

beginnings, everything is still unformed, dark.

WILHELM, PAGE 16

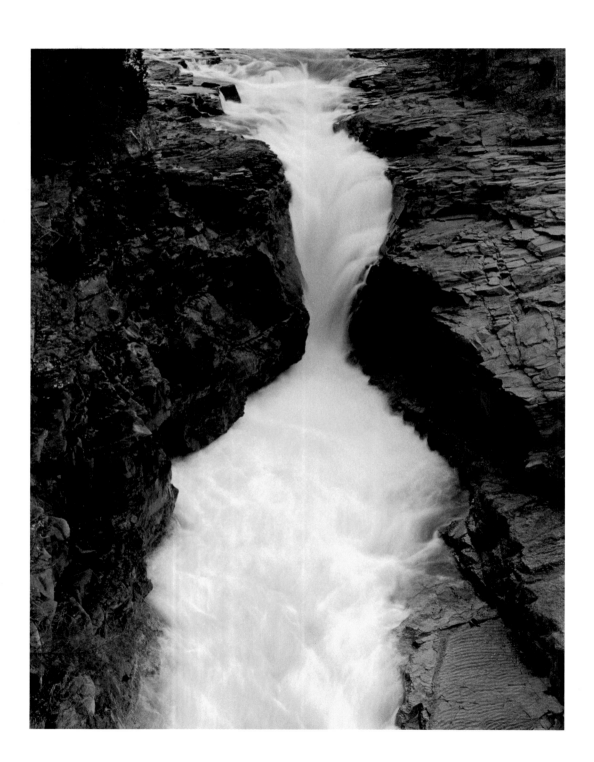

4

MÊNG ∣ YOUTHFUL FOLLY

KÊN ∣ Keeping Still, Mountain

K'AN ∣ The Abysmal, Water

Confusion leading to enlightenment

A small spring at the foot of a mountain

The foot of the mountain symbolizes danger and youth

from which growth to maturity proceeds

Dangers and challenges lie ahead

Success.

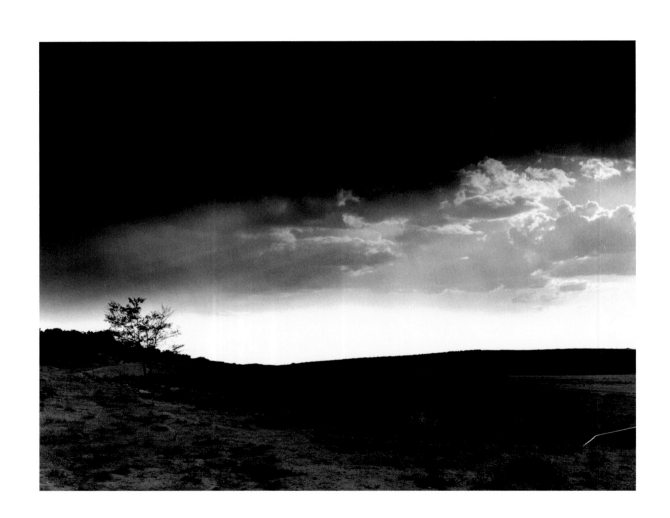

5

HSÜ | **WAITING (NOURISHMENT)**

K'AN | The Abysmal, Water

CH'IEN | The Creative, Heaven

Patience

Waiting

Danger lies ahead

In the heavens, water takes the form of clouds

Moisture rises to the heavens as it prepares to fall

All life will be nourished.

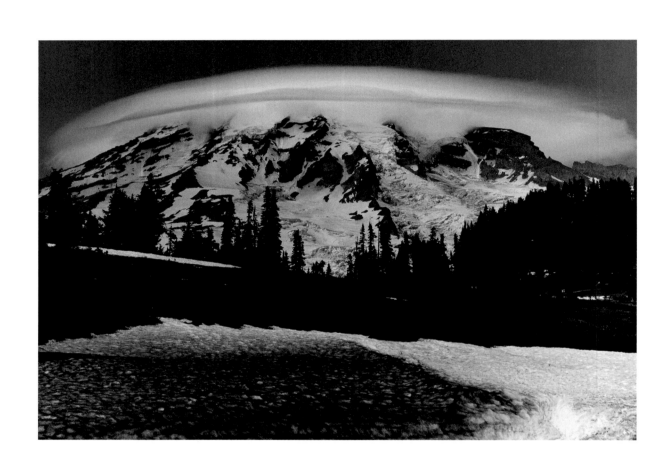

6

SUNG | CONFLICT

CH'IEN | The Creative, Heaven

K'AN | The Abysmal, Water

Strength above and danger below

Conflict

Heaven and water are in opposition

As they draw further apart,

there is great discord

Consider action carefully

It is not the time to initiate dangerous enterprises.

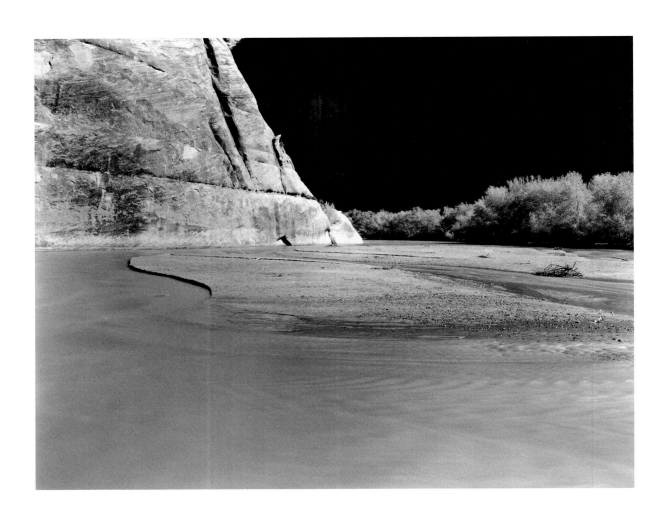

7

SHIH | THE ARMY

K'UN | The Receptive, Earth

K'AN | The Abysmal, Water

Water flowing beneath the earth is an
invisible source of power
Strength arises when people are brought together
Mass
The earth is expansive
Water represents service and sustenance
Everything flows toward water.

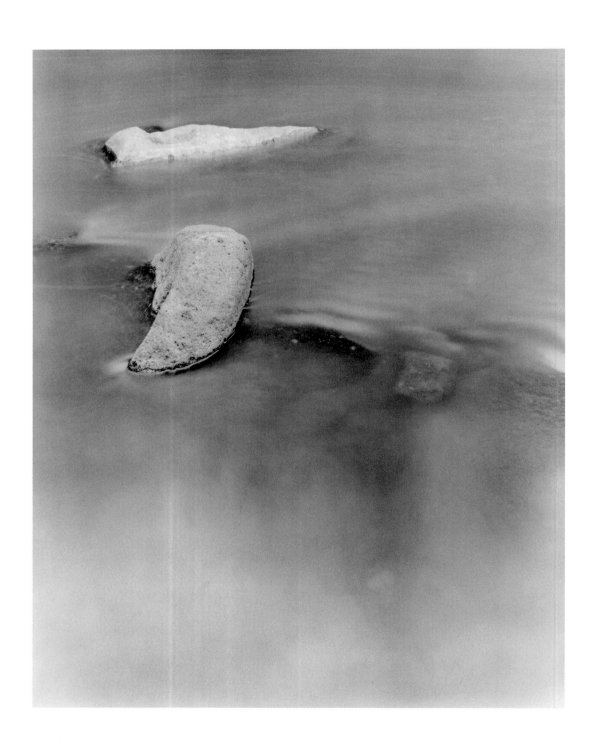

8

PI | HOLDING TOGETHER (UNION)

K'AN | The Abysmal, Water

K'UN | The Receptive, Earth

Water unites as the rivers flow

toward the ocean

Greatness of spirit, consistency and strength

Union

As water merges and gives moisture to the earth,

so should there be unity and flow in society.

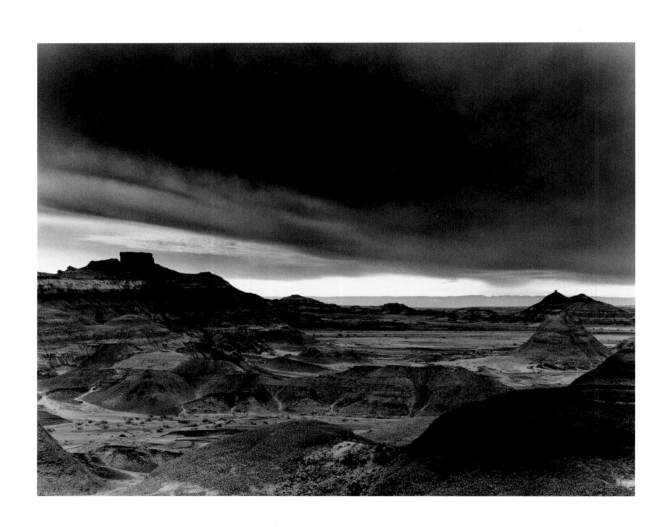

9

HSIAO CH'U | THE TAMING POWER OF THE SMALL

SUN | The Gentle, Wind

CH'IEN | The Creative, Heaven

Dense clouds but no rain

The force of the small

Wind is everywhere, blowing across the sky,

penetrating,

restraining the clouds

Although the wind is forceful enough

to form clouds,

it is not strong enough to cause rain.

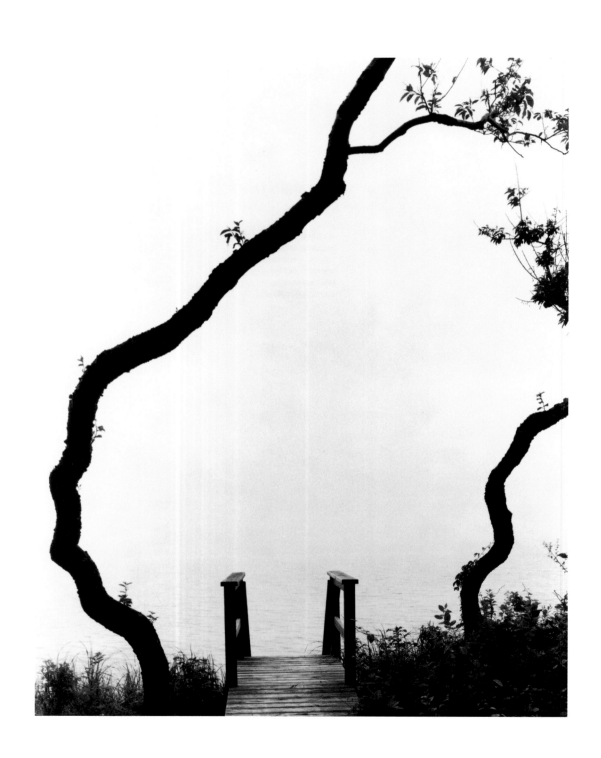

10

LÜ | TREADING (CONDUCT)

CH'IEN | The Creative, Heaven

TUI | The Joyous, Lake

The weak is behind the strong
One walks behind the other, moving in
the same direction
Heaven is above the lake
Differences of elevation exist
in nature and in mankind
Right conduct
Success.

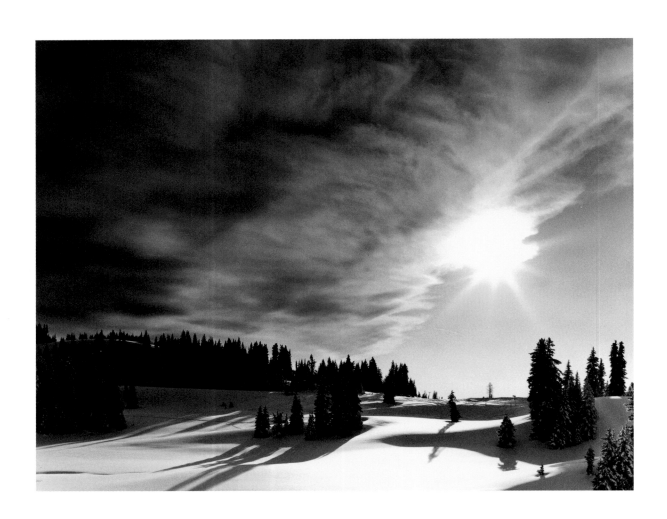

11

T'AI | PEACE

K'UN | The Receptive, Earth
CH'IEN | The Creative, Heaven

Heaven and earth unite
Upper and lower unite
Everything becomes one
There is light on the inside,
darkness on the outside.

Heaven has placed itself beneath the earth,
and so their powers unite in deep harmony.
Then peace and blessing descend upon all living things.

WILHELM, PAGE 48

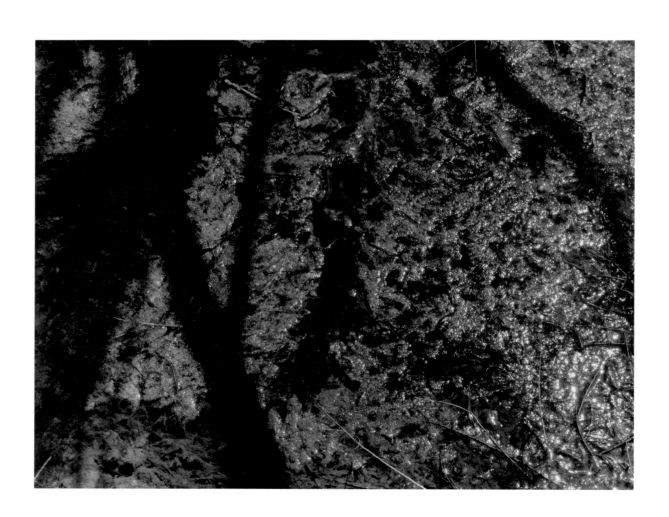

12

P'I | STANDSTILL (STAGNATION)

CH'IEN | The Creative, Heaven

K'UN | The Receptive, Earth

Heaven and earth are out of harmony

The natural world is in decline

Stagnation

On the inside weakness,

on the outside harshness

Dark is within

The light has been pushed to the outside.

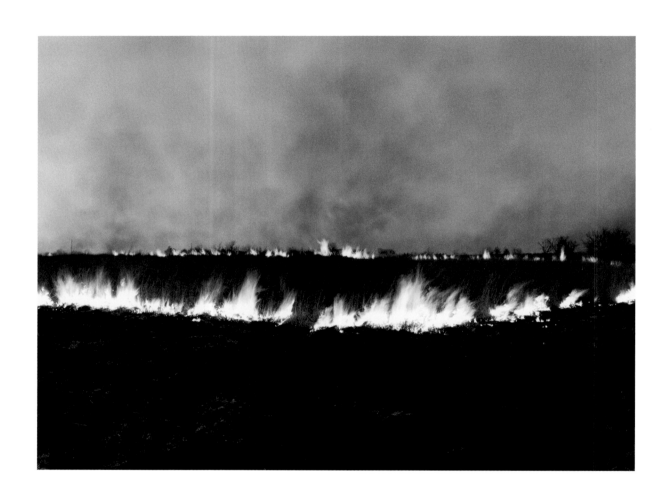

13

T'UNG JÊN | FELLOWSHIP WITH MAN

CH'IEN | The Creative, Heaven

LI | The Clinging, Flame

Fellowship among humanity
Universal concerns prevail
As the sun favors all things equally,
seek order, clarity
equality and union.

Heaven has the same direction of movement as fire,
yet it is different from fire.

WILHELM, PAGE 57

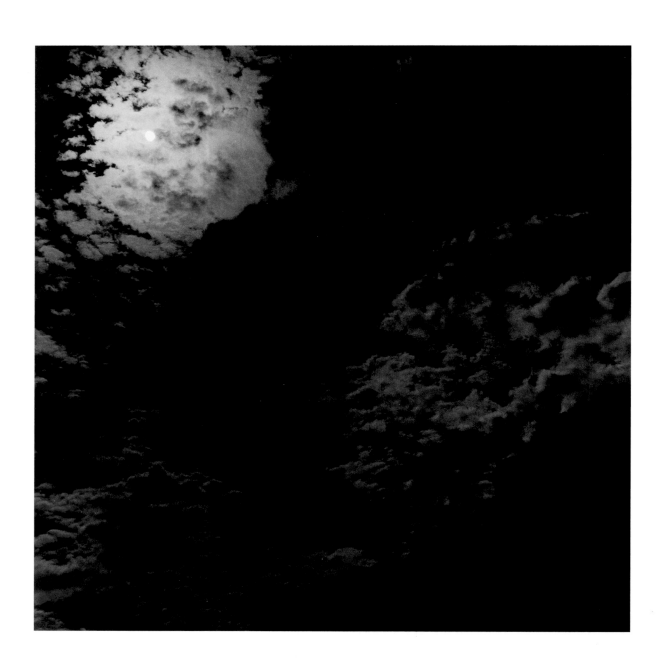

14

TA YU | POSSESSION IN GREAT MEASURE

LI | The Clinging, Flame
CH'IEN | The Creative, Heaven

Firmness
Solidity and strength come from inside
Heaven's light shines on everything
Possession in great measure brings success.

The sun brings both evil and good into the light of day. Man must combat and curb the evil, and must favor and promote the good.

WILHELM, PAGE 60

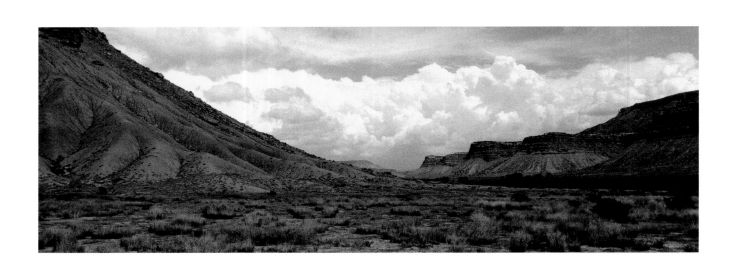

15

CH'IEN | MODESTY

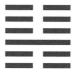

K'UN | The Receptive, Earth

KÊN | Keeping Still, Mountain

The mountain is the image of modesty,
spreading radiance
The superior man moves in harmony
when heaven influences earth.

*The wealth of the earth in which a mountain is hidden is not
visible to the eye, because the depths are offset by the height of the mountain.*

WILHELM, PAGE 64

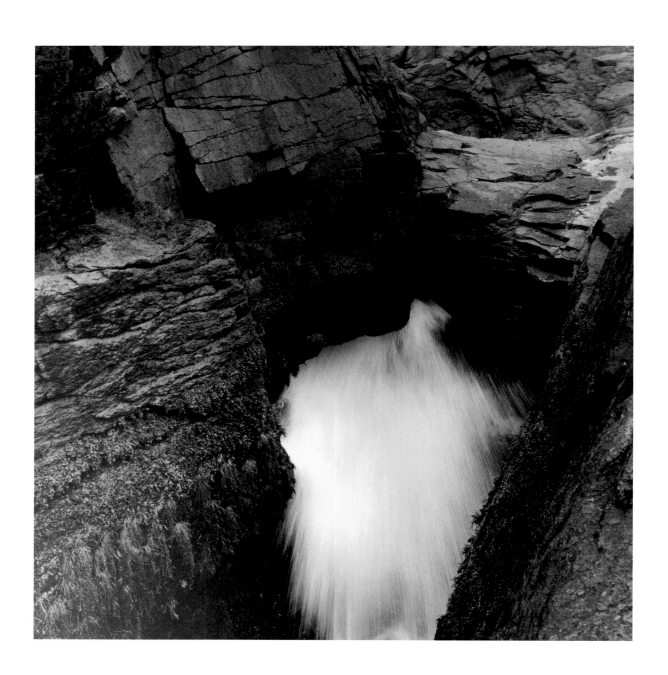

16

YÜ | ENTHUSIASM

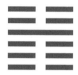

CHÊN | The Arousing, Thunder

K'UN | The Receptive, Earth

Enthusiasm

Heaven and earth move with devotion

Thunder is over the earth

There is a reawakening of life

Energy rushes forth and refreshes the earth

Tension is resolved

A supreme deity emerges.

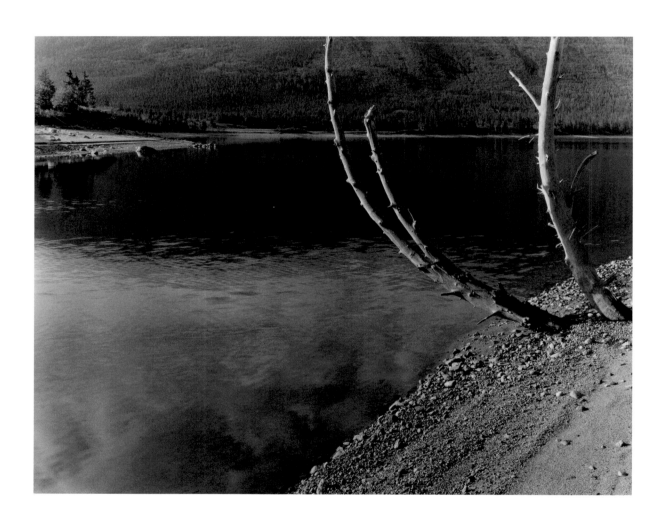

17

SUI | **FOLLOWING**

TUI | The Joyous, Lake

CHÊN | The Arousing, Thunder

Autumn

A time of darkness and sleep

Nature adapts, following its natural order

Activity ebbs

The earth and man are quiet

Thunder is at rest in the middle of the lake.

KU | WORK ON WHAT HAS BEEN SPOILED (DECAY)

KÊN | Keeping Still, Mountain

SUN | The Gentle, Wind

Decay

A new beginning

The wind stirs things up

Vegetation spoils

There is stagnation

The mountain and lake offer tranquility

and nourishment to everything

The spirit grows.

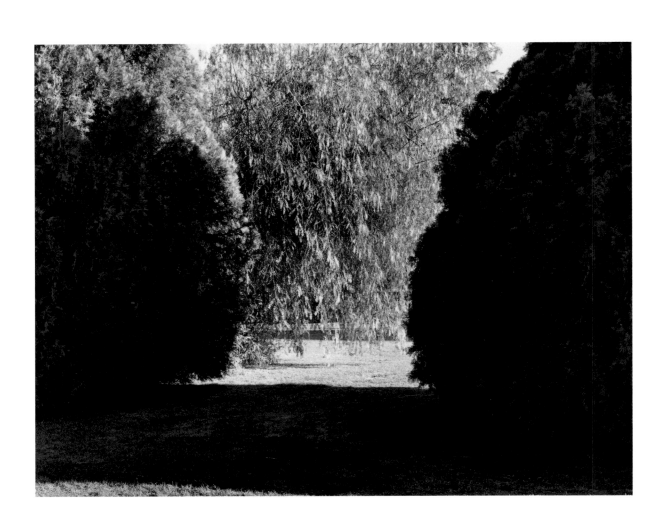

19

LIN | APPROACH

K'UN | The Receptive, Earth

TUI | The Joyous, Lake

After the winter solstice,
the light ascends again and spring begins
The earth is expansive and abundant,
caring for all creatures,
continuously teaching.

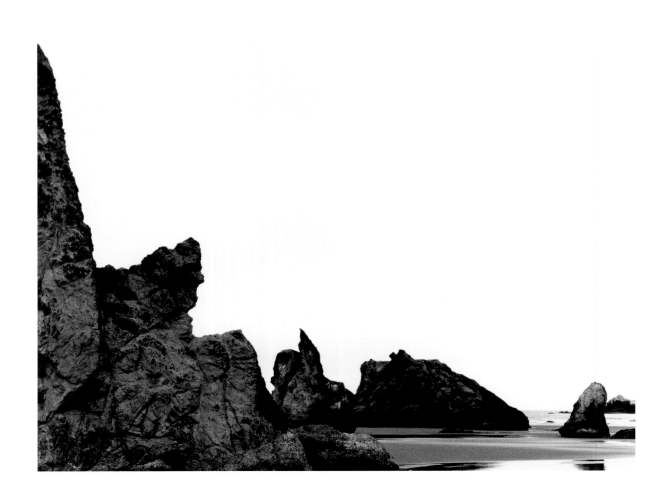

20

KUAN | **CONTEMPLATION (VIEW)**

SUN | The Gentle, Wind

K'UN | The Receptive, Earth

Contemplation
Developing strength and faith
As the seasons change, we reflect
on what has gone before and what
will come next
Devoted and gentle.

When the wind blows over the earth it goes far and wide,
and the grass must bend to its power.

WILHELM, PAGE 83

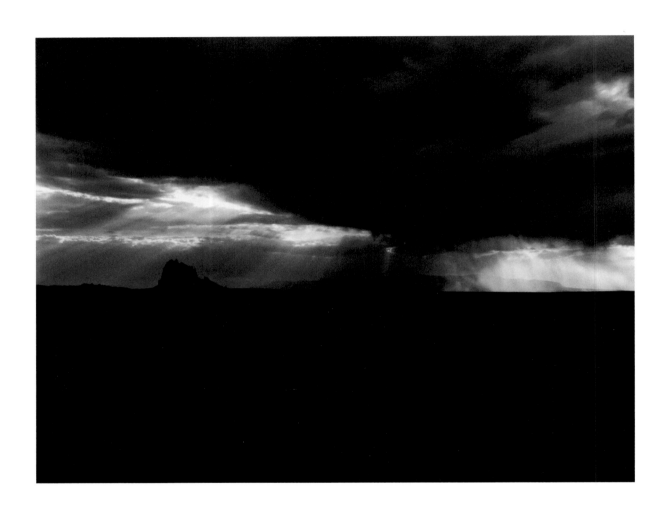

21

SHIH HO | BITING THROUGH

LI | The Clinging, Fire

CHÊN | The Arousing, Thunder

Biting through barriers

As thunder and lightning remove obstacles in nature,

obstacles must be overcome with great purpose

The light is high and radiates across the land,

giving clarity

Lightning reveals all that is hidden in the darkness,

yet there is turmoil

Thunder and lightning are united below.

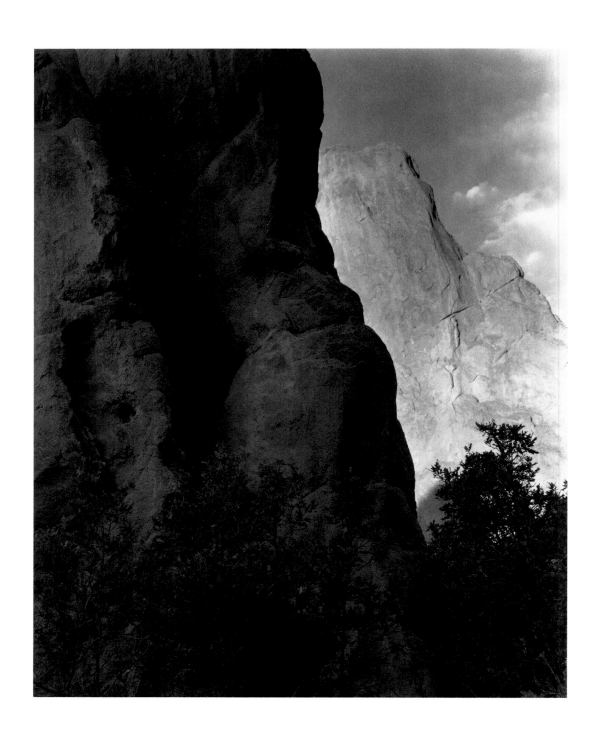

22

PI | GRACE

KÊN | Keeping Still, Mountain

LI | The Clinging, Fire

From the depths of the earth,

fire illuminates and beautifies the mountain

Balance

The sun gives life to the earth, but night must also come

Graceful, ordered behavior, firmness, and justice

Clarity within, quiet without

Contemplation and rest

Unembellished truth.

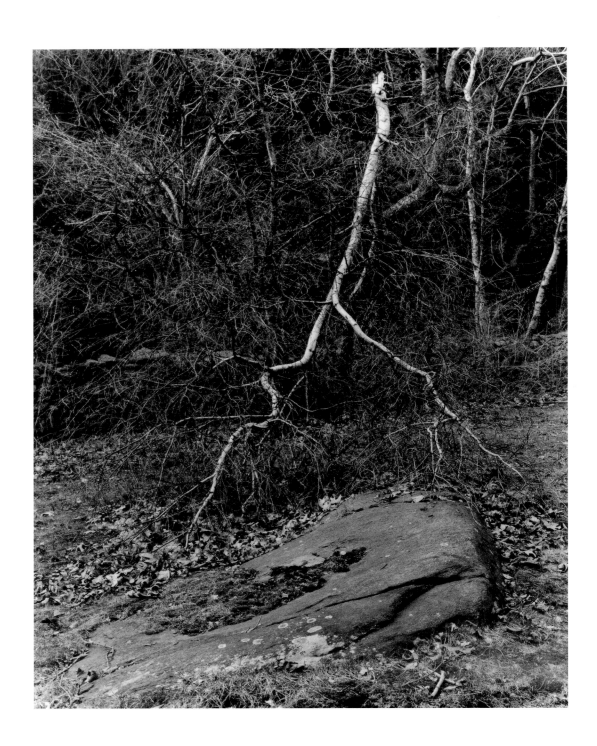

23

PO | SPLITTING APART

KÊN | Keeping Still, Mountain

K'UN | The Receptive, Earth

Decay and deterioration

A grain of wheat sinks into the earth

The ninth month, summer is over

Winter has come, making the land dormant

It is a time of waiting

Emptiness and fullness

As fruit falls to the earth, new fruit

germinates from the disintegration of the old.

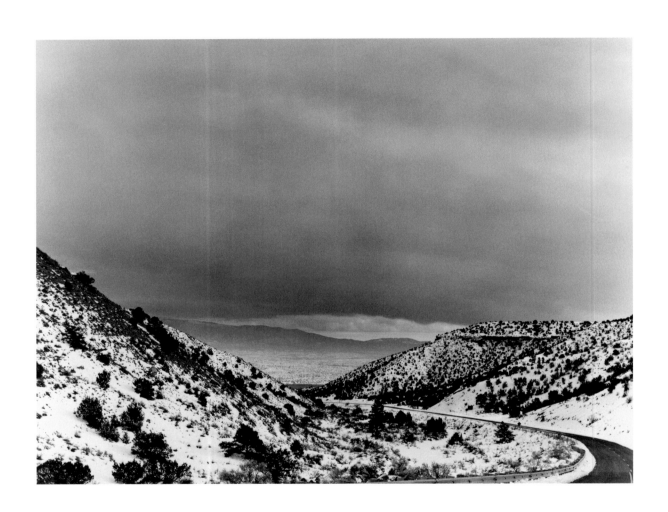

24

FU ｜ **RETURN (THE TURNING POINT)**

K'UN ｜ The Receptive, Earth

CHÊN ｜ The Arousing, Thunder

Light and energy are renewed

The creative power of heaven and earth returns

Movement is from below, proceeding upward

Winter and darkness are past

Reversal

Life is nourished in tranquility

The awakening thunder is strengthened by its rest.

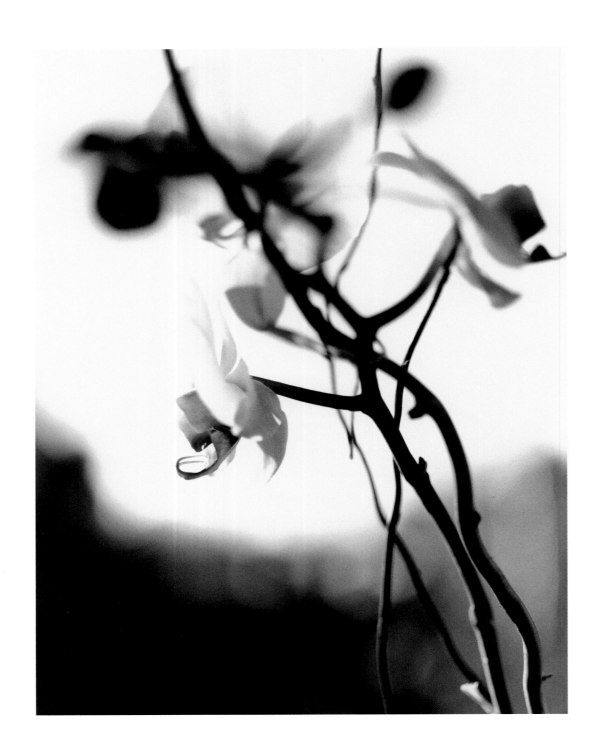

25

WU WANG | INNOCENCE (THE UNEXPECTED)

CH'IEN | The Creative, Heaven

CHÊN | The Arousing, Thunder

Under heaven thunder rolls

Creative energy

Spring

Surging life

Everything grows to attain

a natural state of innocence.

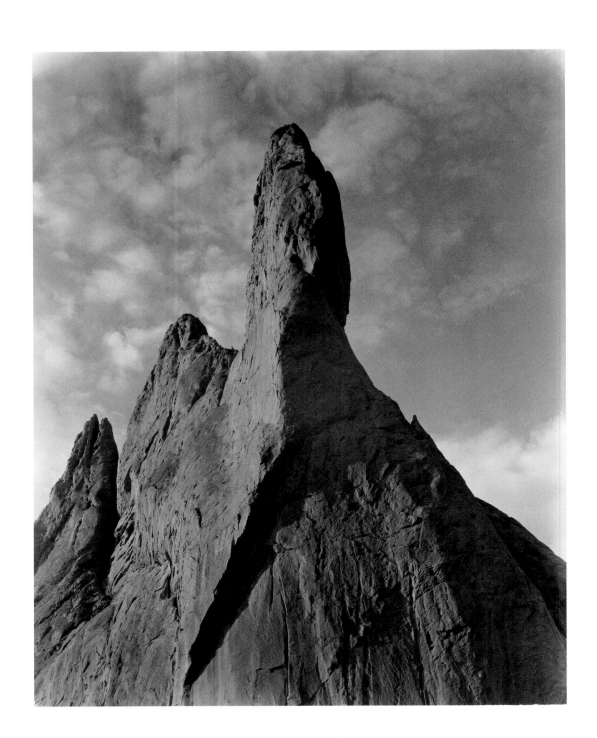

26

TA CH'U | THE TAMING POWER OF THE GREAT

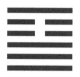

KÊN | Keeping Still, Mountain

CH'IEN | The Creative, Heaven

Firmness and strength

Genuineness and truth

Brilliance and light

Daily renewal of character

Creativity, power and energy.

The way to study the past is not to confine oneself
to mere knowledge of history but, through application
of this knowledge, to give actuality to the past.

WILHELM, PAGE 105

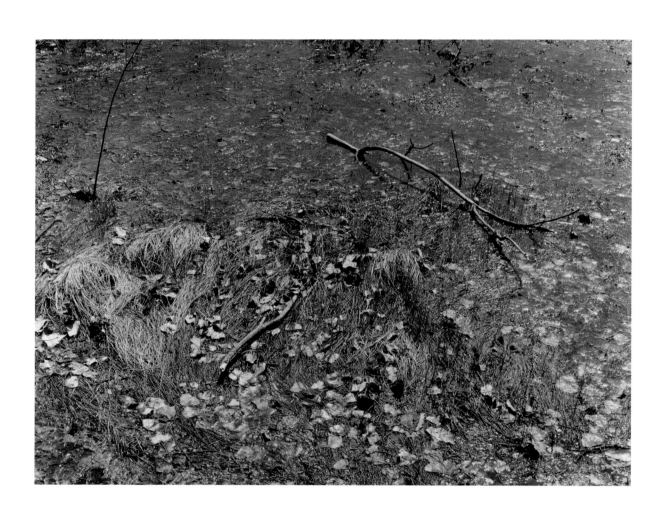

27

I | THE CORNERS OF THE MOUTH
(PROVIDING NOURISHMENT)

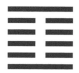

KÊN | Keeping Still, Mountain
CHÊN | The Arousing, Thunder

Nature provides sustenance to all creatures
Give nourishment first to others
In early spring, seeds fall to the earth
as preparation for growth
Following nature's pattern, through observation,
we cultivate our own character
Nurturing through movement and tranquility.

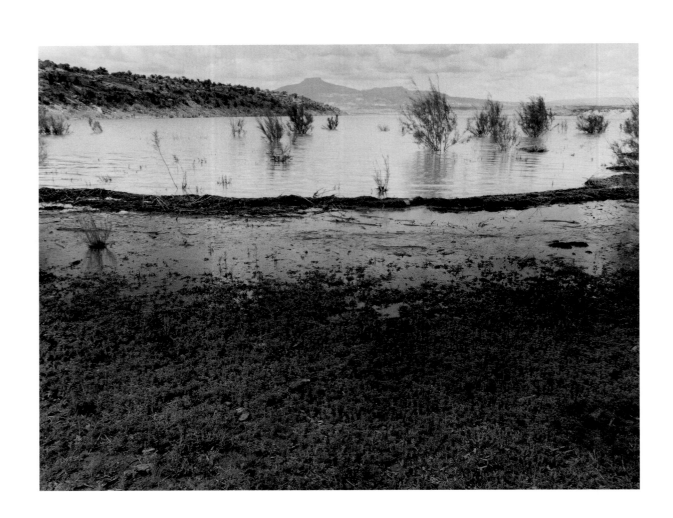

28

TA KUO | PREPONDERANCE OF THE GREAT

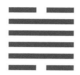

TUI | The Joyous, Lake

SUN | The Gentle, Wind, Wood

The lake rises over the treetops
Although this is temporary, there is danger
The ridgepole sags to the breaking point,
heavy in the center and weak at the ends
The weight of the great is excessive
Extraordinary measures are required.

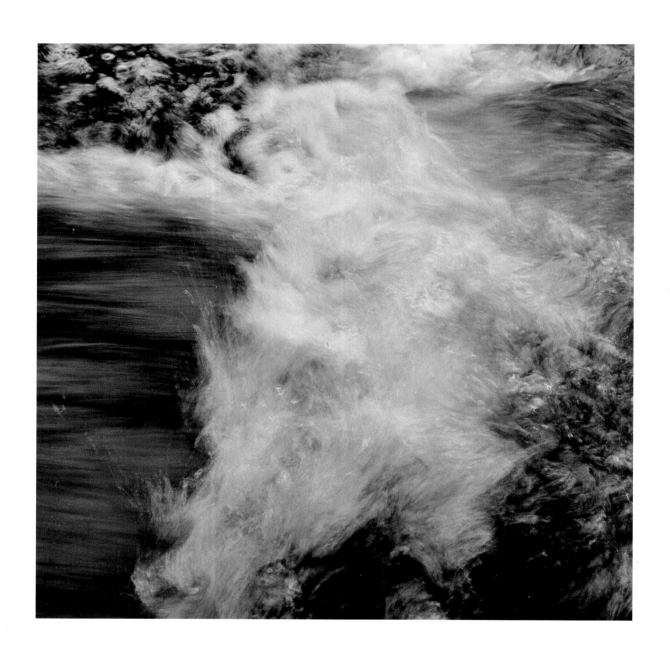

29

K'AN | **THE ABYSMAL (WATER)**

K'AN | The Abysmal, Water

K'AN | The Abysmal, Water

Downward motion

Water is moving from the heavens,

not from the earth

As water flows until it reaches its goal,

it fills all before it

Passing through dangerous places

it is continuous and dependable

So does the superior being remain steadfast.

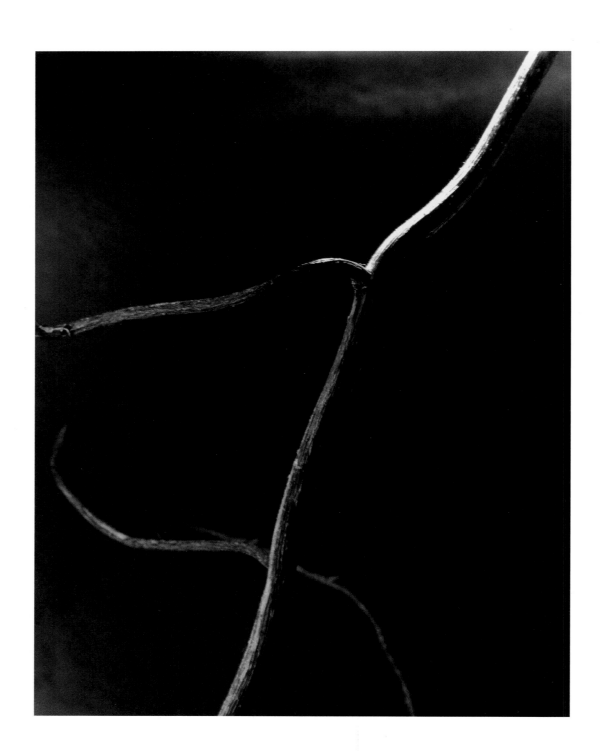

30

LI ⎮ THE CLINGING, FIRE

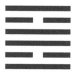

LI ⎮ The Clinging, Fire

LI ⎮ The Clinging, Fire

Fire has no distinct form

It clings to objects

The flame rises

The image is of radiance in nature

Luminosity must be tended or it will burn itself out.

Everything that gives light is dependent on something
to which it clings, in order that it may continue to shine.
Thus sun and moon cling to heaven, and grain, grass, and
trees cling to the earth.

WILHELM, PAGE 119

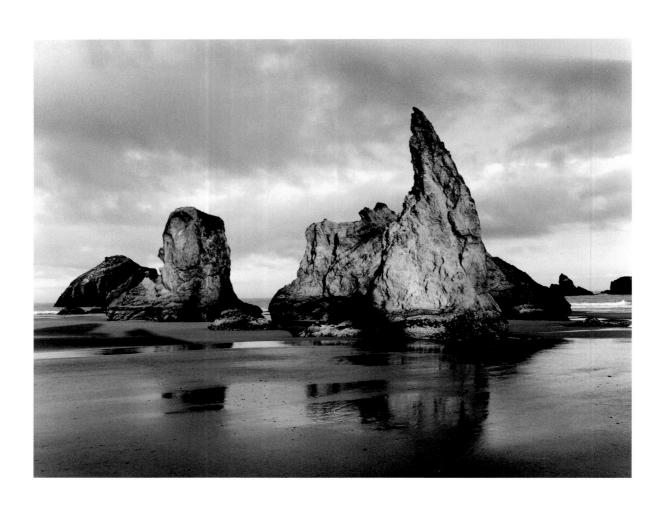

31

HSIEN | INFLUENCE (WOOING)

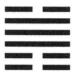

TUI | The Joyous, Lake

KÊN | Keeping Still, Mountain

Heaven and earth are working together
The lake gives moisture to the mountain as
the mountain collects clouds to feed the lake
Weakness is above
Strength is below
Union.

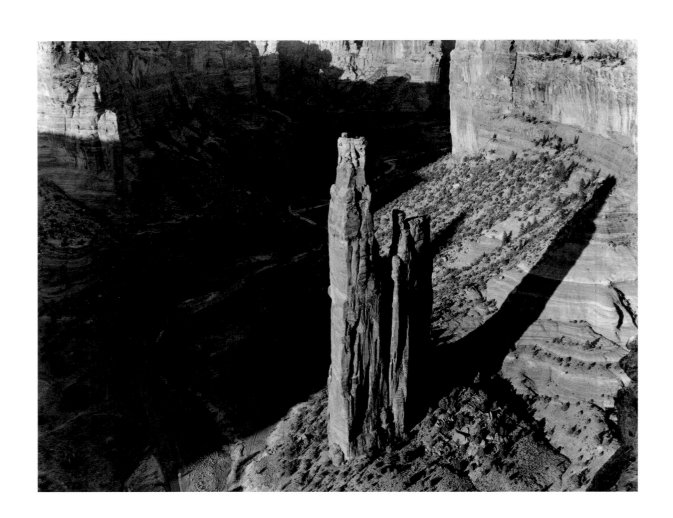

32

HÊNG | DURATION

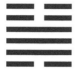

CHÊN | The Arousing, Thunder

SUN | The Gentle, Wind

Enduring union

Marriage

Self-renewal

Persistence despite hindrances

Strength of character

Strength is above

Weakness is below

Thunder rolls and wind penetrates

Working together, standing firm.

33

TUN | RETREAT

CH'IEN | The Creative, Heaven

KÊN | Keeping Still, Mountain

The light seeks sanctuary
where darkness cannot intrude
Withdrawal is proper
The mountain is steadfast and steep
Heaven is strength
Adversity retreats with inner strength.

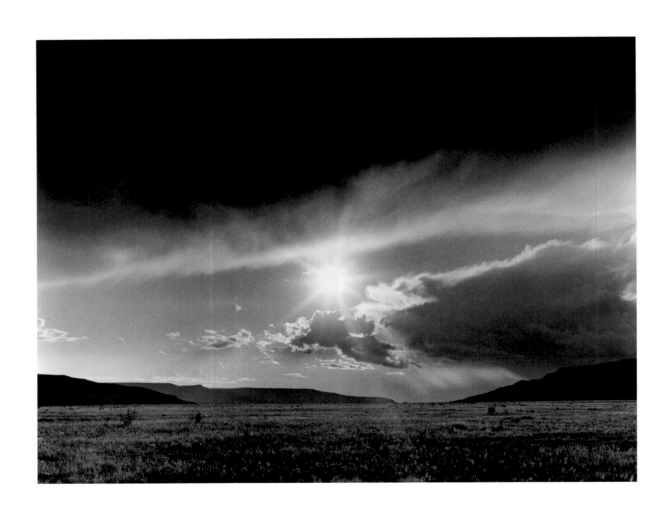

34

TA CHUANG | THE POWER OF THE GREAT

CHÊN | The Arousing, Thunder

CH'IEN | The Creative, Heaven

Fusion of movement and strength

Justice

Thunder is in heaven

Power and greatness reign supreme

Without rightness there is no greatness

Heaven and earth are in balance.

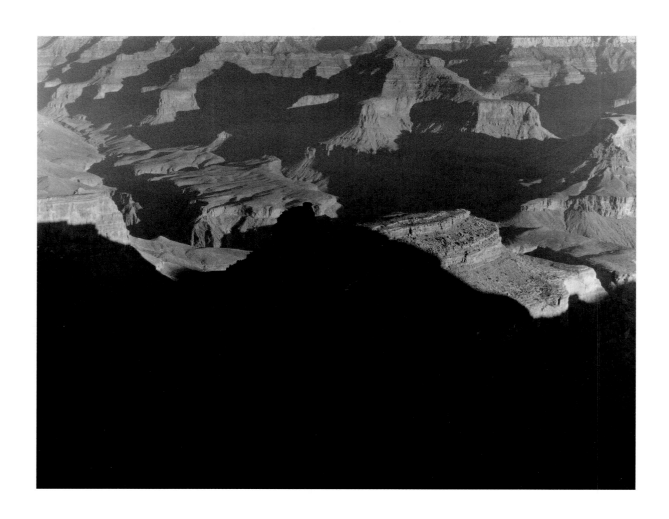

35

CHIN | PROGRESS

LI | The Clinging, Fire

K'UN | The Receptive, Earth

In the natural progression of a day,

the sun rises high over the earth

All is clear

Expansion

Lucidity

Sanctity.

The higher the sun rises, the more it emerges
from the dark mists, spreading the pristine purity
of its rays over an ever widening area.

WILHELM, PAGE 137

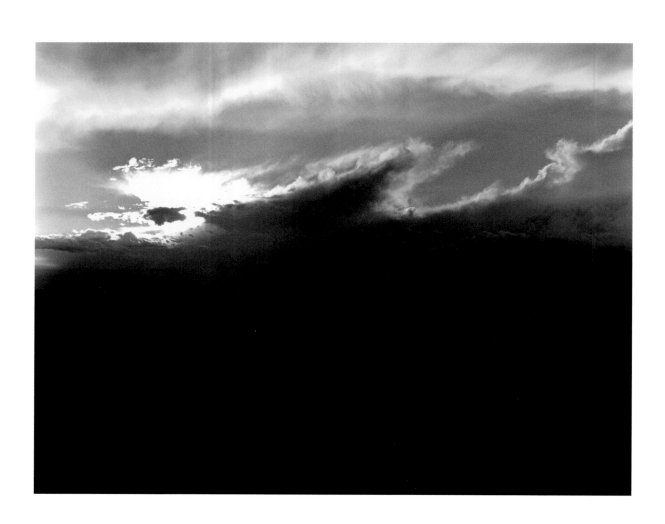

36

MING I | DARKENING OF THE LIGHT

K'UN | The Receptive, Earth

LI | The Clinging, Fire

The sun has sunk below the earth's horizon

Wounding of the bright

The dark nature is in power and can bring harm

Adversity

Maintain inner light

Persevere

In darkness caution is necessary.

Thus does the superior man live with great mass:

He veils his light, yet still shines.

WILHELM, PAGE 140

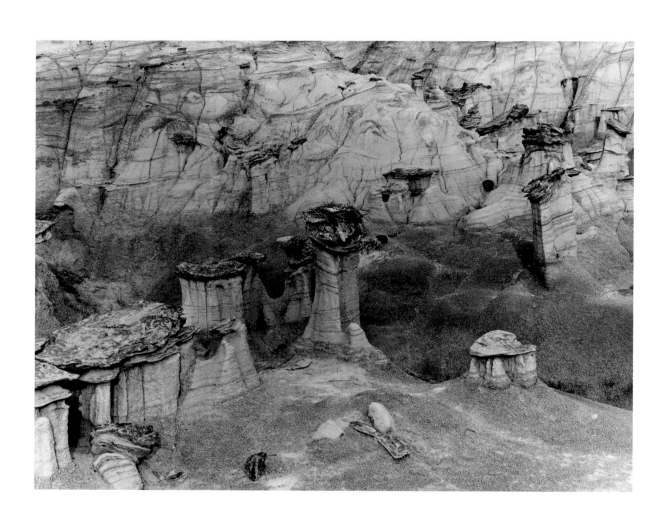

37

CHIA JÊN | THE FAMILY (THE CLAN)

SUN | The Gentle, Wind

LI | The Clinging, Fire

Consistency in words and conduct

Relationships

Connections

Dedication to the interests of the family

over the interests of the individual

Clear communication.

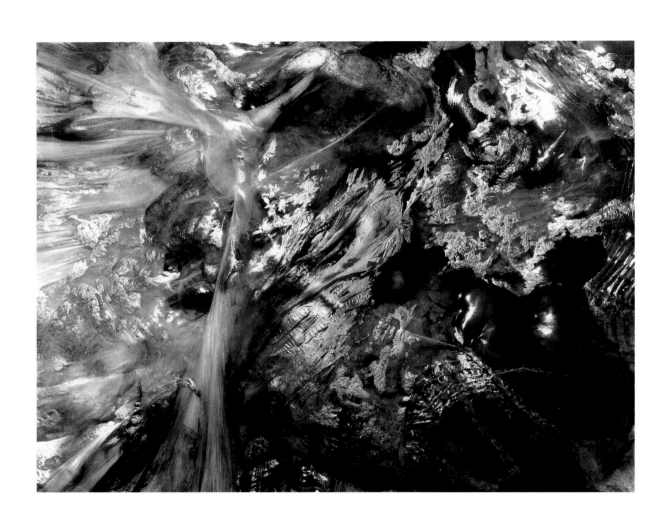

38

K'UEI | OPPOSITION

LI | The Clinging, Flame

TUI | The Joyous, Lake

Opposition and obstructions are present

Avoid great undertakings

Opposition does not preclude agreement

Maintain inner strength

Preserve individuality while understanding differences.

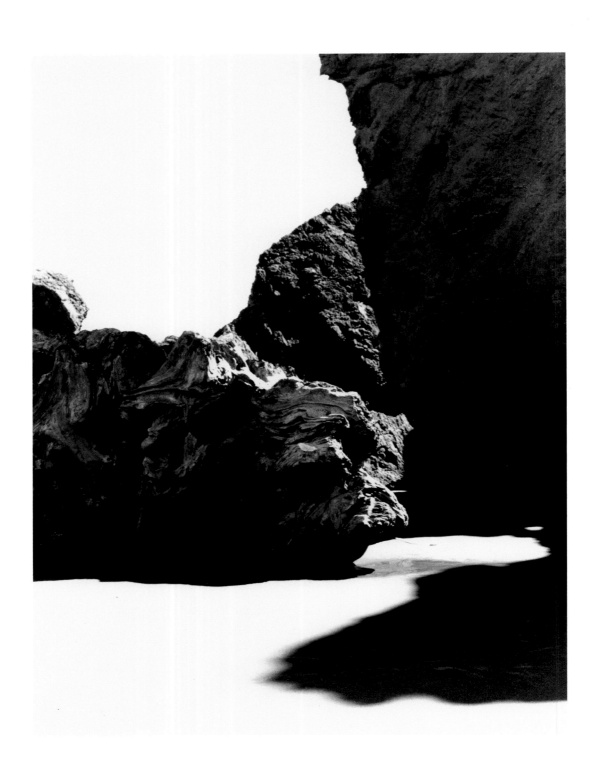

39

CHIEN | OBSTRUCTION

K'AN | The Abysmal, Water

KÊN | Keeping Still, Mountain

Danger lies ahead

An abyss in front, a steep mountain behind

When surrounded by obstacles, reflect and retreat

Observe and prepare to overcome dangers

Introspection is necessary for success

Blame causes failure.

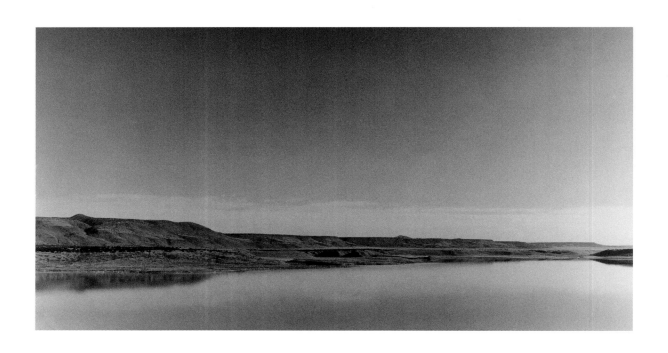

40

HSIEH | DELIVERANCE

CHÊN | The Arousing, Thunder

K'AN | The Abysmal, Water

Thunderstorms release tension in the atmosphere

Obstacles are removed

Complications ease

It is a time of deliverance

Do not exalt triumph or push further than necessary

Restore order.

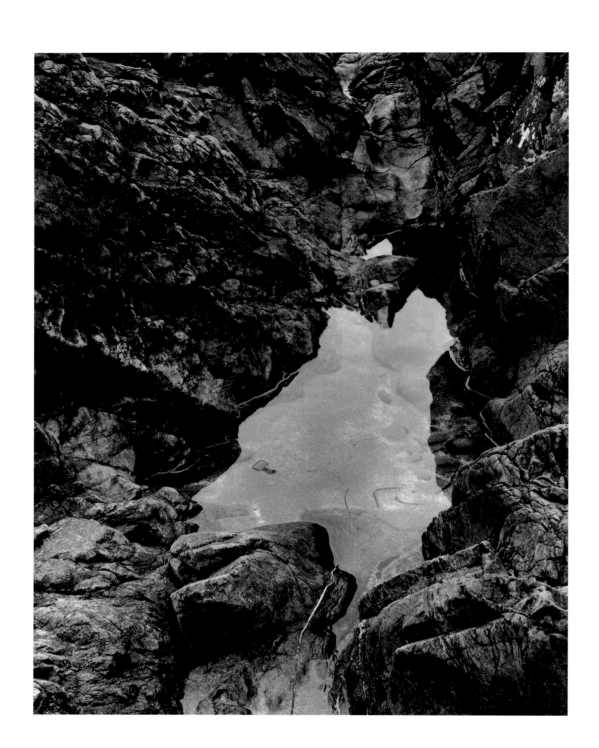

41

SUN | DECREASE

KÊN | Keeping Still, Mountain

TUI | The Joyous, Lake

Things increase and decrease
according to natural rhythms
Face inevitability
Simplify and observe
Avoid concealment
Benefit from sacrifices now;
they will lead to a later flowering.

The lake at the foot of the mountain evaporates. In
this way it decreases to the benefit of the mountain, which
is enriched by its moisture.

WILHELM, PAGE 159

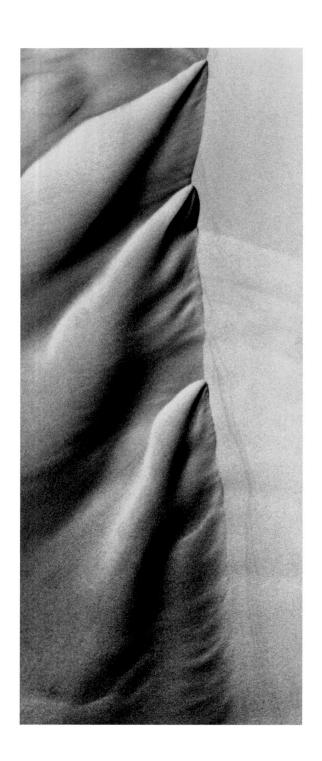

42

I | INCREASE

SUN | The Gentle, Wind

CHÊN | The Arousing, Thunder

Thunder and wind increase,

strengthening each other

Observe and imitate

Abandon evil, embrace good

There is great energy for worthwhile endeavors

Progress and successful development

All can benefit.

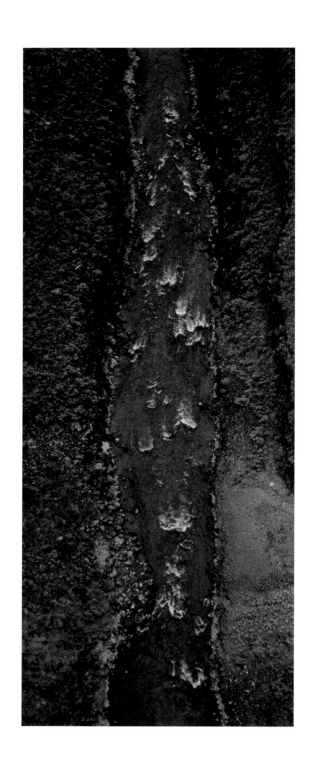

43

KUAI | BREAK-THROUGH (RESOLUTENESS)

TUI | The Joyous, Lake

CH'IEN | The Creative, Heaven

Personal struggle

Good against evil

Ideas must change

Declare them with great clarity

Do not compromise

Be strong without the use of force

Be sincere with awareness and authority

Remain receptive and continue self-examination.

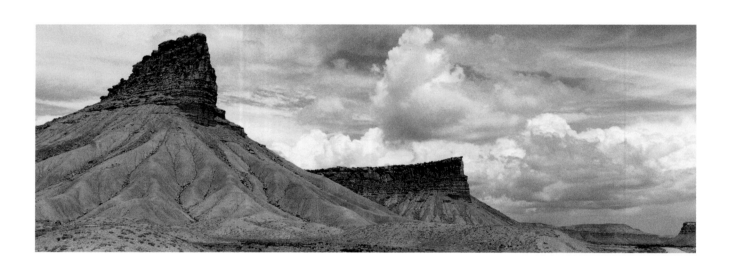

44

KOU | COMING TO MEET

CH'IEN | The Creative, Heaven

SUN | The Gentle, Wind

Though heaven is far from earth, its effects are felt

Winds come from the heavens, bringing change

Do not grant darkness power

Observation is necessary to prevent lasting harm

The strong and the weak should meet halfway,

free of ulterior motives

Actions bring change

Sudden enlightenment may follow.

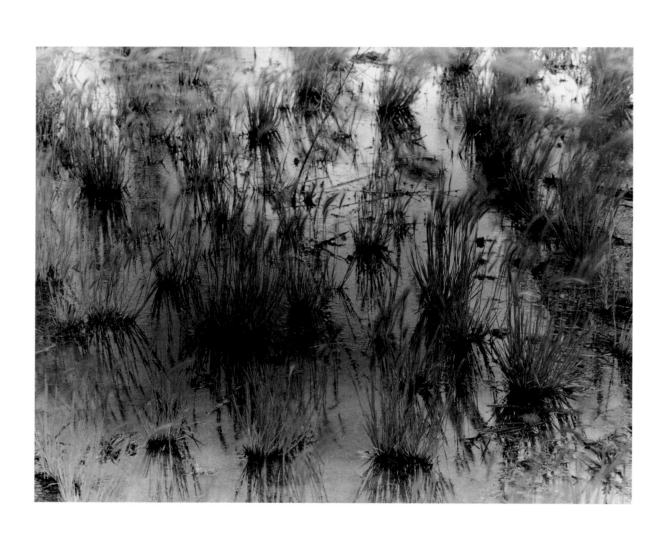

45

TS'UI | GATHERING TOGETHER (MASSING)

TUI | The Joyous, Lake

K'UN | The Receptive, Earth

Water collects in the lake

and swells until it rises above the earth

Take precautions to prevent overflow

Gather family and community

Spiritual forces are needed

When many people come together, strife may occur

Sacrifice to the ancestors to keep everyone together.

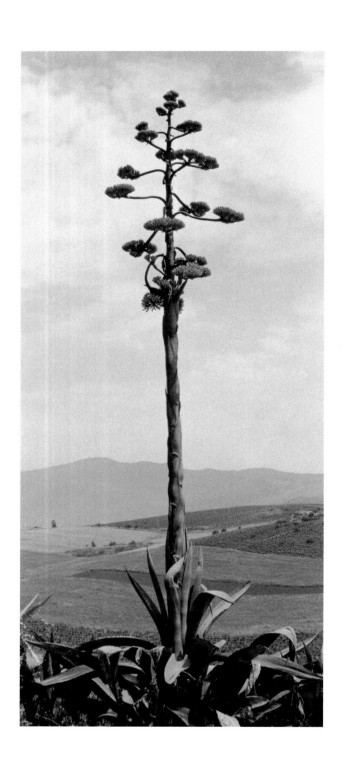

46

SHÊNG | PUSHING UPWARD

K'UN | The Receptive, Earth

SUN | The Gentle, Wind, Wood

Wood grows upward,

neither rushing nor hesitating

A plant needs energy to emerge from the earth

Upward movement is not accomplished through agitation

but with humility, flexibility, and grace.

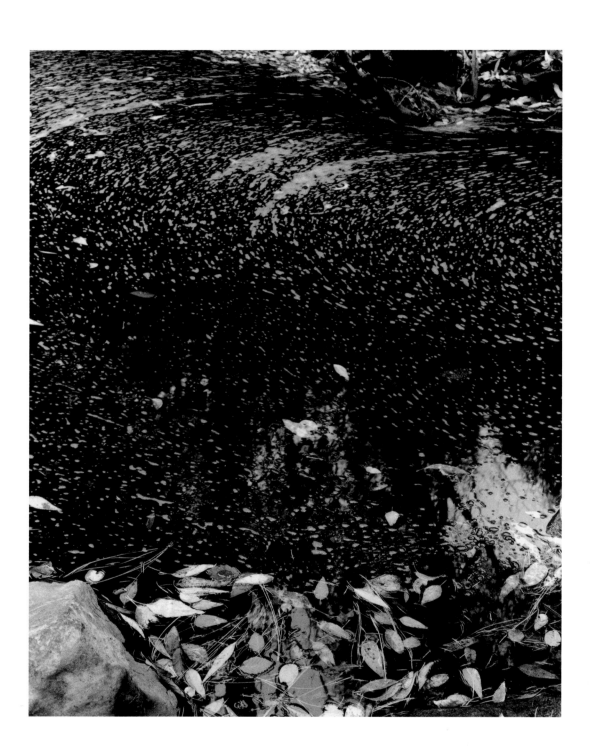

47

K'UN | **OPPRESSION (EXHAUSTION)**

TUI | The Joyous, Lake

K'AN | The Abysmal, Water

The power of the dark confronts

the power of the light

The superior man is restrained

by the inferior man

Adversity

Remain stable and steadfast

Help comes through offerings and meditation

Aid others and the empty lake will fill again.

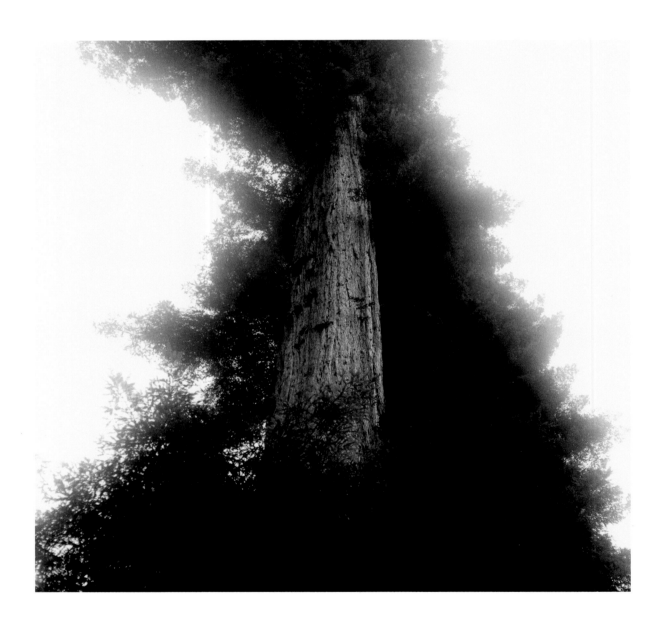

48

CHING | THE WELL

K'AN | The Abysmal, Water

SUN | The Gentle, Wind, Wood

Constant nourishment

Plants lift water from the earth through their roots

The well must remain dependable and stable

Society must remain stable,

then the land is blessed.

. . . the life of man with its needs remains eternally the same. . . .
Life is also inexhaustible; . . . it exists for one and for all. . . . And every
human being can draw, in the course of his education, from the
inexhaustible wellspring of the divine in man's nature.

WILHELM, PAGE 186

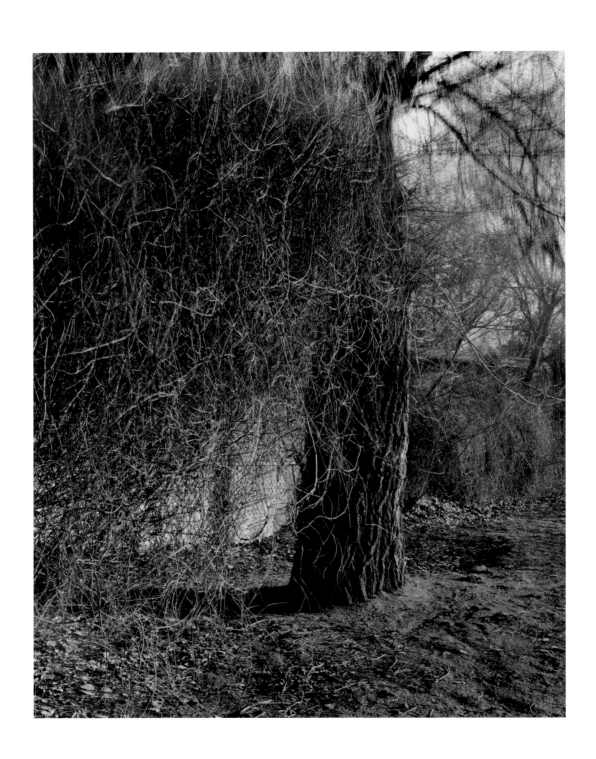

49

KO | **REVOLUTION (MOLTING)**

TUI | The Joyous, Lake

LI | The Clinging, Fire

Animals molting

Seasons and times changing

Conflict between lake and fire

Undertake revolution only when no other options exist

Follow nature's path

Be free of selfish aims.

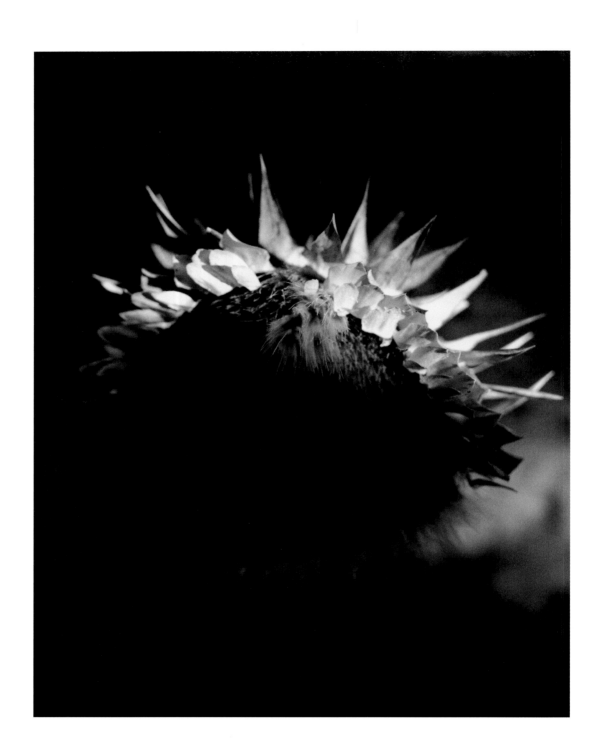

50

TING | **THE CALDRON**

LI | The Clinging, Fire

SUN | The Gentle, Wind, Wood

The Ting, an ancient Chinese serving vessel,

symbolizes nourishment

Foster and nurture worthy men and women

Wood and wind below,

fire above

Food is prepared.

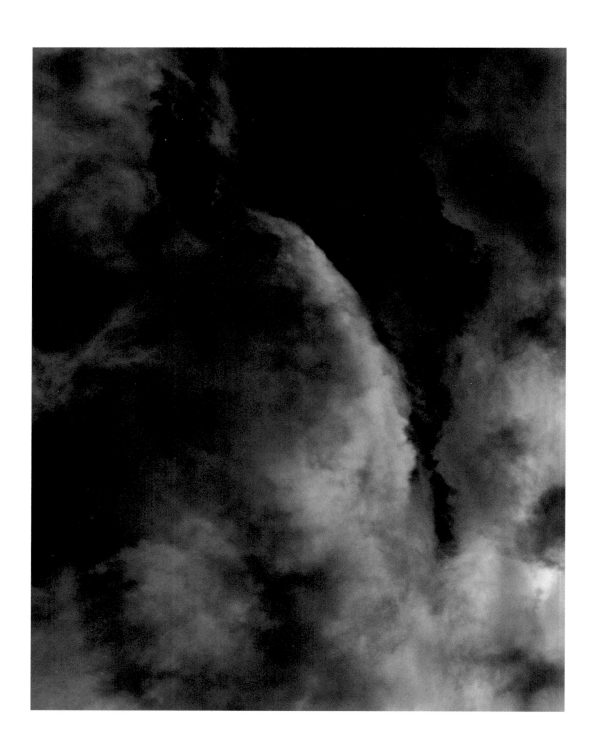

51

CHÊN | THE AROUSING (SHOCK, THUNDER)

CHÊN | The Arousing, Thunder

CHÊN | The Arousing, Thunder

Energy and power

Thunder rolls from the earth

Violent movement

Terror is aroused

Revere the prowess of the natural world

Seek knowledge of self

Respect, joy, and merriment will follow.

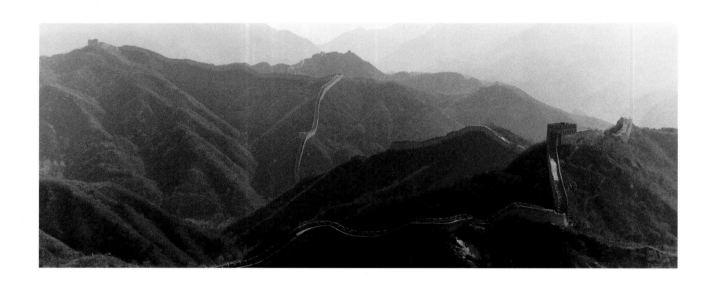

52

KÊN | KEEPING STILL, MOUNTAIN

KÊN | Keeping Still, Mountain

KÊN | Keeping Still, Mountain

Mountains poised side by side

Quiet

Be still or move forward at appropriate times

Peace of mind is needed to unravel

the mysteries of the universe

When we act from depth there are no mistakes.

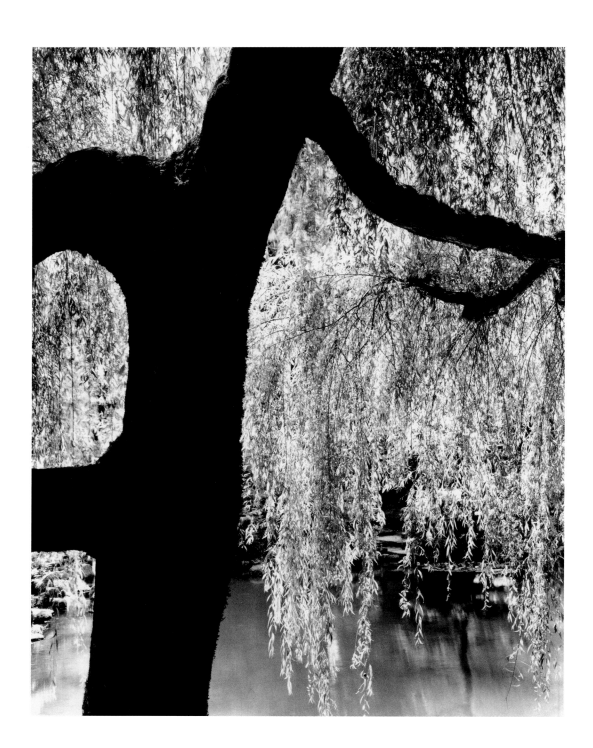

53

CHIEN | DEVELOPMENT (GRADUAL PROGRESS)

SUN | The Gentle, Wind, Wood

KÊN | Keeping Still, Mountain

Wood

Mountain

A tree grows slowly and stands firmly rooted

following the rhythm of nature

The lone tree influences the landscape

Tranquility

Dignity and virtue

Fidelity.

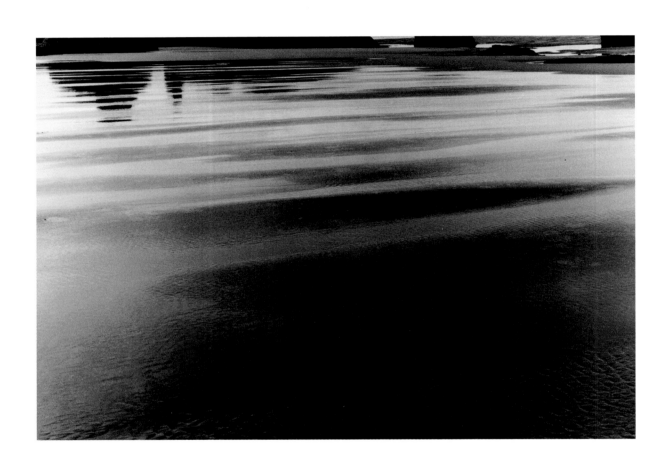

54

KUEI MEI | THE MARRYING MAIDEN

CHÊN | The Arousing, Thunder

TUI | The Joyous, Lake

Thunder over the lake

The water in the lake follows the ways of the thunder

As in nature, human relationships require nurturing

Danger lurks in every relationship

Be mindful.

Thunder stirs the water of the lake,

which follows it in shimmering waves.

WILHELM, PAGE 210

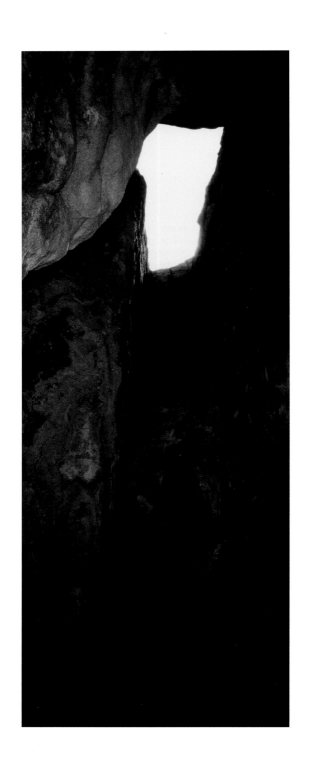

55

FÊNG | ABUNDANCE (FULLNESS)

CHÊN | The Arousing, Thunder

LI | The Clinging, Flame

Flame

Clarity within, movement without

Greatness and abundance

The sun at midday is bright

Everything is in its rightful place

Thunder and lightning bring abundance

but do not last long

Be prepared to receive abundance

and preserve it for later.

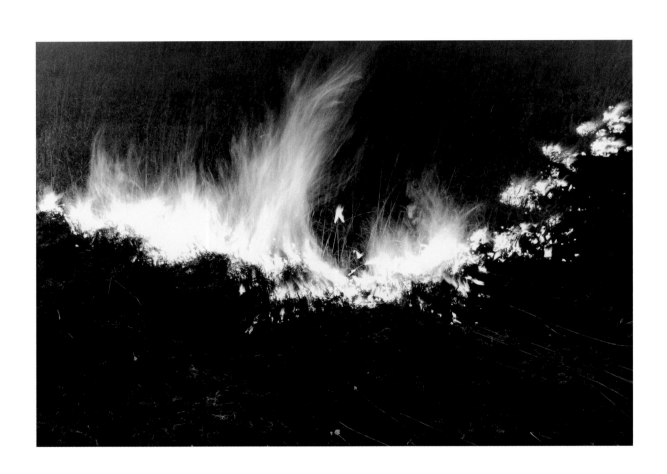

56

LÜ | THE WANDERER

LI | The Clinging, Flame

KÊN | Keeping Still, Mountain

Fire on the mountain

A grass fire produces bright light but moves quickly

The wise wanderer, traveling from one place

to another, treats others with respect

The fire comes and goes like

. . . *a stranger in a strange land.*

WILHELM, PAGE 218

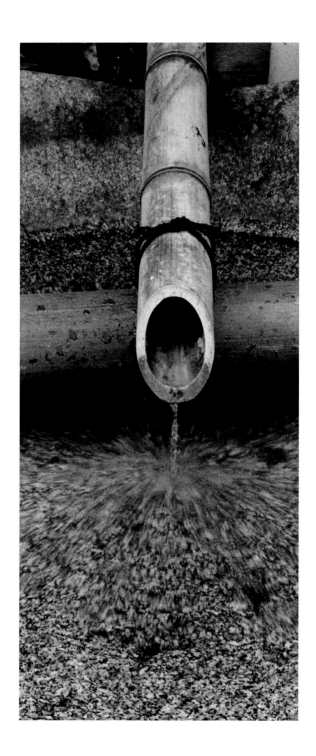

57

SUN | THE GENTLE (THE PENETRATING, WIND)

SUN | The Gentle, Wind, Wood

SUN | The Gentle, Wind, Wood

Constant, gentle movement brings
good fortune and success
Ceaselessness
Chase off evil spirits and hesitation
Be firm with decisions
Turn to others for help and support.

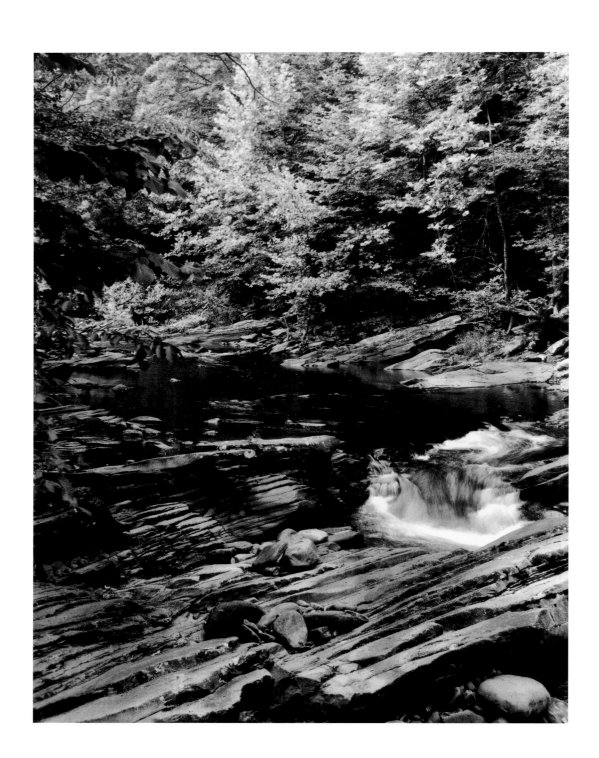

58

TUI | THE JOYOUS, LAKE

TUI | The Joyous, Lake

TUI | The Joyous, Lake

Joy comes from inner strength

and outer gentility

Joy brings success

but must not be exaggerated.

Truth and strength must dwell in the heart. . . .
A lake evaporates upward and thus gradually dries up;
but when two lakes are joined they do not dry up
so readily, for one replenishes the other.

WILHELM, PAGE 224

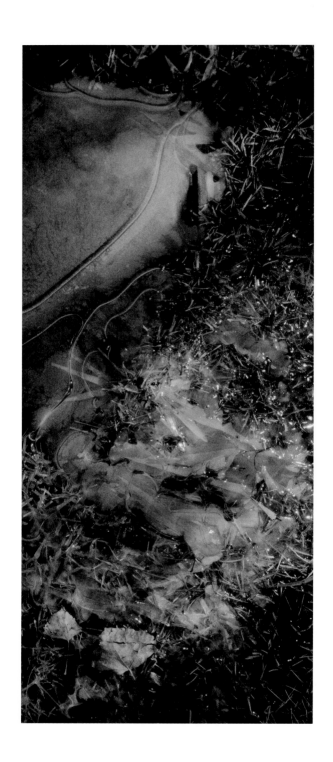

59

HUAN ı DISPERSION (DISSOLUTION)

SUN ı The Gentle, Wind

K'AN ı The Abysmal, Water

After the winter frost, the spring thaw begins
Warm breezes dissolve the ice
Nature is chaotic, then unified
Strength derives from nature's unity.

It is a rare time for society and individuals
Let go of ego, it promotes isolation
Make commitments to common causes
Seek community and family.

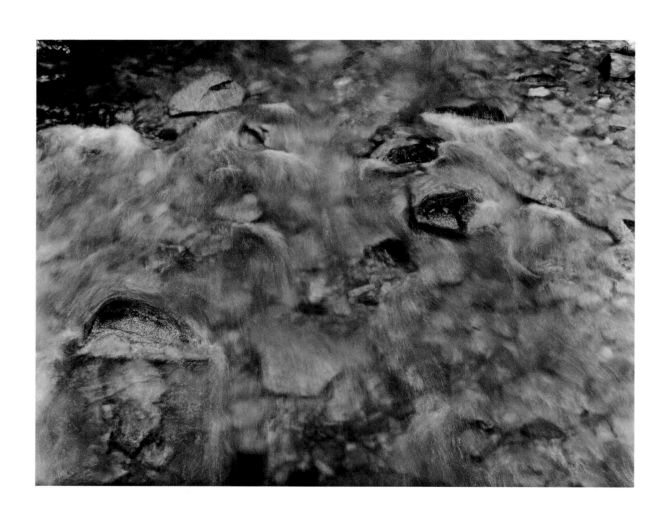

60

CHIEH | LIMITATION

K'AN | The Abysmal, Water

TUI | The Joyous, Lake

Even though water is inexhaustible,

the lake can only hold a given quantity

Without limits the water overflows, causing harm

As nature sets limits, so must we

Time and order are marked

by the change of seasons.

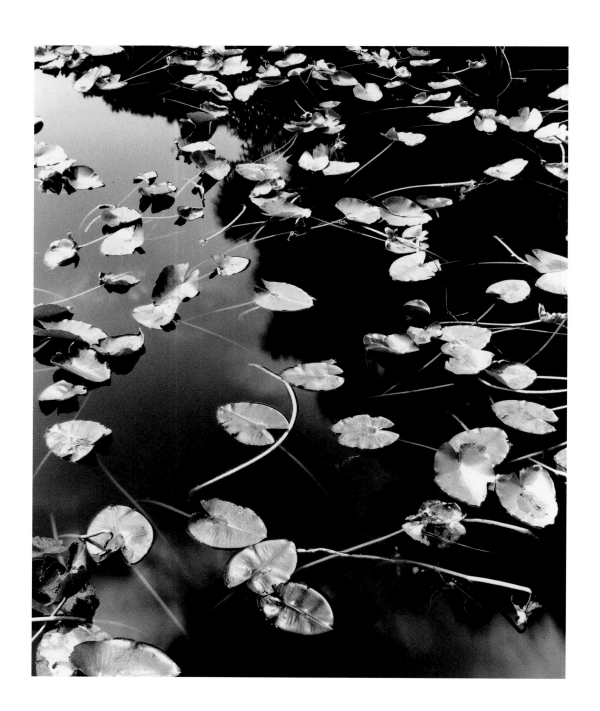

61

CHUNG FU | INNER TRUTH

SUN | The Gentle, Wind

TUI | The Joyous, Lake

Wind over the lake

Insight and empathy

Inner truth fosters compassion

Empathizing with others promotes self-discovery.

A deep understanding that knows how to pardon

was considered the highest form of justice.

WILHELM, PAGE 236

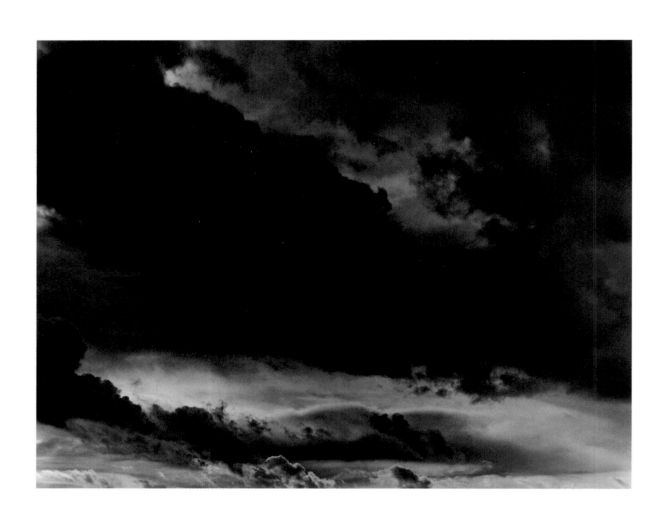

62

HSIAO KUO | PREPONDERANCE OF THE SMALL

CHÊN | The Arousing, Thunder

KÊN | Keeping Still, Mountain

Thunder over the mountain

In the mountains the crash of thunder is louder

Look carefully

Be humble, modest, and conscientious

It is a time to keep still,

to bow to duty and responsibility.

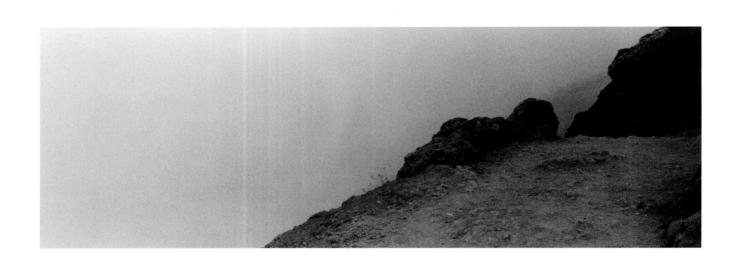

63

CHI CHI | AFTER COMPLETION

K'AN | The Abysmal, Water

LI | The Clinging, Fire

The transition from disorder to order is complete

Everything is in its proper place

Caution and quiet are necessary to prevent chaos

Any movement may destroy order

Good fortune at the beginning

can lead to misfortune at the end

Water over fire generates energy.

If the water boils over, the fire is extinguished and its energy is lost.

If the heat is too great, the water evaporates into the air.

WILHELM, PAGE 245

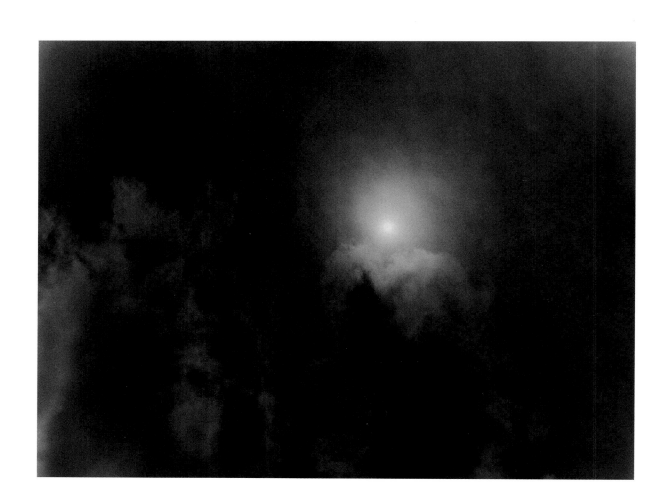

64

WEI CHI | **BEFORE COMPLETION**

LI | The Clinging, Flame

K'AN | The Abysmal, Water

The transition from disorder to order is not complete

All is prepared, but conditions are difficult

Caution and responsibility are necessary for success

Transformation from the stagnation of winter

to spring and summer

Success

Fulfillment will be achieved.

List of Plates

1. **CH'IEN | THE CREATIVE**
 Bisti Badlands, New Mexico, 1984
 David Scheinbaum

2. **K'UN | THE RECEPTIVE**
 Rio Grande Gorge, Taos, New Mexico, 1978
 David Scheinbaum

3. **CHUN | DIFFICULTY AT THE BEGINNING**
 Diablo Canyon, New Mexico, 1986
 David Scheinbaum

4. **MÊNG | YOUTHFUL FOLLY**
 Woodstock, New York, 1973
 David Scheinbaum

5. **HSÜ | WAITING (NOURISHMENT)**
 Rain Clouds, Santa Fe, New Mexico, 1984
 Janet Russek

6. **SUNG | CONFLICT**
 Mt. Rainier, Washington, 1976
 David Scheinbaum

7. **SHIH | THE ARMY**
 Canyon de Chelly, Arizona, 1984
 David Scheinbaum

8. **PI | HOLDING TOGETHER (UNION)**
 Two Stones, Jemez River, New Mexico, 1992
 Janet Russek

9. **HSIAO CH'U | THE TAMING POWER OF THE SMALL**
 Sunset, Bisti Badlands, New Mexico, 1985
 Janet Russek

30. **LI | THE CLINGING, FIRE**
Stem, 2000
Janet Russek

31. **HSIEN | INFLUENCE (WOOING)**
Bandon Beach, Oregon, 1989
David Scheinbaum

32. **HÊNG | DURATION**
Spider Rock, Canyon de Chelly, Arizona, 1984
Janet Russek

33. **TUN | RETREAT**
Ghost Ranch, New Mexico, 1993
David Scheinbaum

34. **TA CHUANG | THE POWER OF THE GREAT**
Sunset, Piedra Lumbre, Ghost Ranch,
New Mexico, 1991
Janet Russek

35. **CHIN | PROGRESS**
Grand Canyon National Park, Arizona, 1999
Janet Russek

36. **MING I | DARKENING OF THE LIGHT**
Ghost Ranch, New Mexico, 1991
David Scheinbaum

37. **CHIA JÊN | THE FAMILY (THE CLAN)**
Bisti Badlands, New Mexico, 1985
David Scheinbaum

38. **K'UEI | OPPOSITION**
Jellyfish, Maine, 1982
Janet Russek

39. **CHIEN | OBSTRUCTION**
Bandon Beach, Oregon, 1989
Janet Russek

Bibliography

Ch'eng I. *Shen-i-t'ang I Ching* (The I Ching from the Studio of Cautious Transmission). Pei-ching, China, 1885.

Legge, James, trans. *The I Ching*. 2nd ed. New York: Dover Publications, 1963.

Mote, Frederick W. *Intellectual Foundations of China*. New York: Alfred A. Knopf, 1971.

Neeham, Joseph. *Science and Civilization in China*. Vol. 2, *History of Scientific Thought*. Cambridge, England: Cambridge University Press, 1962.

Schwartz, Benjamin I. *The World of Thought in Ancient China*. Cambridge, Mass.: Harvard University Press, 1985.

Shaughnessy, Edward L. *Before Confucius: Studies in the Creation of the Chinese Classics*. Albany: State University of New York Press, 1997.

Smith, Richard J. *China's Cultural Heritage: The Ch'ing Dynasty 1644–1912*. Boulder, Colo.: Westview Press, 1983.

Wilhelm, Hellmut. *Eight Lectures on the I Ching*. Cary F. Baynes, trans. Princeton, N.J.: Princeton University Press, 1973.

Wilhelm, Richard, trans. *The I Ching or Book of Changes*. 3rd ed. Princeton, N.J.: Princeton University Press, 1950, 1967.

Suggested Reading

Book of Changes, An Interpretation for the Modern Age. Text by Chan Chiu Ming. Asiapac Books, Singapore, 1997.

The Buddhist I Ching. Chih-hsu Ou-I. Translated by Thomas Cleary. Shambala, Boston and London, 1987.

Eight Lectures on the I Ching. Hellmut Wilhelm; translated by Cary F. Baynes. Princeton University Press, Princeton, N.J., 1973.

I Ching. Rudolf Ritsema and Stephen Karcher. Barnes and Noble, New York, 1995.

I Ching: The Book of Change. Translated and edited by John Blofeld. E.P. Dutton and Co., New York, 1968.

The I Ching or Book of Changes. The Richard Wilhelm Translation; rendered into English by Cary F. Baynes. Bollingen Series XIX, Princeton University Press, Princeton, N.J., 1950.

I Ching Clarified: A Practical Guide. Mondo Secter. Charles E. Tuttle Company, Rutland, Vt., and Tokyo, Japan, 1993.

The I Ching Workbook. R. L. Wing. Doubleday and Co., New York, 1979.

The Taoist I Ching. Translated by Thomas Cleary. Shambala, Boston and London, 1986.

Acknowledgments

There are many people to thank for their work and belief in this project. We are forever grateful to Jonathan Porter for his thoughtful and scholarly text. Through his knowledge of the I Ching and his insightful interpretations of the Chinese characters, Jonathan also provided a depth of understanding that was enormously important to us in selecting the photographs.

We would like to thank Michael Motley for his initial design of our book presentation and Dottie Indyke for editing our personal notes.

We thank the Museum of New Mexico Press for their belief in this project. As photographers, and not natural writers, we owe much gratitude to our editors. We are especially appreciative of Ann Mason's insightful suggestions on the individual hexagrams. Her firsthand knowledge of the I Ching added clarity and flow to our words. We are ever grateful to Mary Wachs for her support and enthusiasm as well as her insight into the text, prose, and images. She gave us the courage to believe in our own writing for this project. To David Skolkin, whose energy and excitement was boundless, we stand in awe. He was able to see what we were feeling—to take it to the page—and make this project just what we had dreamed of. David's perceptive design seamlessly melded our images and the sensibility of the I Ching. We thank Anna Gallegos for her support and help with the many details that go into the publication of a book.

We want to acknowledge and thank Princeton University Press for granting us permission to quote extensively from *The I Ching or Book of Changes*, the Richard Wilhelm translation. Over the years we have discovered many fine volumes and interpretations of the I Ching,

but we have always returned to and relied upon this edition first and foremost.

We are deeply grateful to Neil Trager, Director of the Samuel Dorskey Museum of Art at the State University of New York, New Paltz, for his interest, guidance, and for organizing the traveling exhibition of this work.

We would like to acknowledge our friends, students, colleagues, teachers, our mentors Beaumont Newhall and Eliot Porter, and family—all those who have shared in our journey these past twenty-five years. We thank our children, Jonathan and Andra Russek and Zachary Scheinbaum, whose cooperation and patience over the years have made our work possible. They have been inspirational as well as patient. They have sat for many hours on roadsides waiting for us to return.

—JANET RUSSEK AND DAVID SCHEINBAUM,
SANTA FE, 2004